The Besterman World Bibliographies

The Besterman World Bibliographies

Art *and* Architecture

A BIBLIOGRAPHY OF BIBLIOGRAPHIES

By Theodore Besterman

TOTOWA, N. J.
Rowman and Littlefield

1971

Published by
Rowman and Littlefield
A Division of
Littlefield, Adams & Co.
81 Adams Drive
Totowa, N. J. 07512

★

★

Typography by George Hornby
and Theodore Besterman

ISBN 0-87471-045-6

Contents

Preface

I have explained in the Introduction to the successive editions of *A World bibliography of bibliographies* why I decided to arrange it alphabetically by specific subjects. Since that decision was taken, and after prolonged experience of the book in use, I have had no reason to regret it, nor among the many letters I have received from librarians has there been a single one complaining of the alphabetical form of the *World bibliography*.

The *World bibliography of bibliographies* covers all subjects and all languages, and is intended to serve reference and research purposes of the most specific and specialised kind. Yet contained in it are broad and detailed surveys which, if relevant entries throughout the volumes are added to them, can serve also the widest reference inquiries, and be useful to those who seek primary signposts to information in varied fields of inquiry.

Therefore I can only thank Rowman and Littlefield for having gathered together all the titles in some of the major fields found throughout the 6664 columns of the fourth edition (1965-1966) of *A World bibliography of bibliographies*.

Preface

These fields are:

1. Bibliography
2. Printing
3. Periodical Publications
4. Academic Writings
5. Art and Architecture
6. Music and Drama
7. Education
8. Agriculture
9. Medicine
10. Law
11. English and American Literature
12. Technology
13. Physical Sciences
14. Biological Sciences
15. Family History
16. Commerce, Manufactures, Labour
17. History
18. Geography

Of course these categories by no means exhaust the 117,000 separately collated volumes set out in the *World bibliography*, and the above titles will be added to if librarians wish for it.

Th. B.

Notes on the Arrangement

An Alternative to critical annotation

Consider what it is we look for in a normal bibliography of a special subject. Reflection will show, I think, that we look, above all, for completeness, just as we do in a bibliography of bibliographies. We desire completeness even more than accuracy (painfully uncongenial though it is for me to make such a statement); for in most cases a bibliography is intended to give us particulars of publications to which we wish to refer; thus we can always judge for ourselves (waiving gross errors) whether the bibliographer has correctly described these publications. On the other hand, anything that is omitted is lost until rediscovered.

The question is, therefore, whether it is possible to give some indication of the degree of completeness of a bibliography without indulging in the annotation which is impossible in a work of the present scope and scale. It seemed to me that this could be achieved, to a considerable extent, by

recording the approximate number of entries set out in it. This method is, of course, a rough-and-ready one, but experience shows that it is remarkably effective: and I hope that its novelty will not tell against it.

The recording of the number of works set out in a bibliography has another advantage in the case of serial publications: it displays in statistical form the development of the subject from year to year—often in a highly significant manner.

This procedure, then, is that which I have adopted, the number of items in each bibliography being shown in square brackets at the end of the entry. This, I may add, is by no means an easy or mechanical task, as can be judged from the fact that this process, on the average, just about doubles the time taken in entering each bibliography.

Supplementary information in footnotes

I have said that this method of indicating the number of entries is intended to replace critical treatment; but it is not possible to exclude annotation altogether, for a certain minimum of added information is indispensable. Consequently many of my entries will be seen to have footnotes, in which the following types of information are recorded: a few words of explanation where the title is inaccurate, misleading, obscure, or in-

Notes

sufficiently informative; a statement to that effect where a work is in progress, where intermediate volumes in a series have not been published, or where no more have been published; an attempt to clarify complicated series; a note that a book was privately printed or in a limited number of copies, where this does not exceed 500, or in some abnormal manner, as on one side of the leaf, on coloured paper, or in a reproduction of handwriting, or with erratic pagination; when I have come across copies containing manuscript or other added matter, I have recorded the fact; substantial corrections and additions to bibliographies are sometimes published in periodicals, and I have noted a good many of these—but without aiming at anything even remotely approaching completeness, the attainment of which would be impossible. Various minor types of information are also occasionally to be found in the footnotes.

Owing to the great increase in the number of bibliographies reproduced directly from typewritten copy, such publications are designated by an asterisk at the end of the entry; this device saves a good deal of space.

Place of publication

The place of publication is not shown when it is London in the case of an english book and

Notes

Paris in the case of a french one. In the case of a series or sequence of entries, however, the absence of a place of publication means that it is the same as the place last shown in the series. The same applies to the names of editors and compilers. The place of publication is given as it appears on the titlepage, but prepositions are omitted even if violence is done to grammatical construction.

The Order of entries

Under each heading the order of the entries is chronological by date of publication; in the case of works in successive volumes or editions the chronological order applies to the first volume or edition. In suitable long headings an additional chronological order by period covered has been created; see, for instance, France: History, or Drama: Great Britain.

Method of collating

An effort has been made, so far as space allows, to give detailed and accurate information of the kind more usually found in small bibliographies. For instance, I have paid special attention to the collation of bibliographies in several (or even numerous) parts or volumes. It is, in fact, difficult to understand why it is usually considered necessary to give collations of works in a single volume,

where difficulties seldom occur (from the point of view of systematic bibliography), but not of a work in several volumes, where confusion much more frequently arises. An occasional gap in the collations of such publications will be noticed. This is because, naturally enough, I have not been able in every case to see perfect sets; and I have thought it better to leave a very small number of such blanks rather than to hold up the bibliography indefinitely.

Serial publications

Where successive issues of a serial publication are set out, the year or period shown is usually that covered by the relevant issue; in such cases no date of publication is given unless publication was abnormal or erratic in relation to the period covered.

Bibliographies in more than one edition

Where a bibliography has gone into more than one edition I have tried (though I have not always been able) to record at least the first and latest editions. Intermediate editions have also been recorded wherever it seemed useful to do so, that is, for bibliographies first published before 1800, and for those of special interest or importance; but in general intermediate editions, though examined, have not been recorded.

Notes

Transcription of titles

Titles have been set out in the shortest possible form consistent with intelligibility and an adequate indication of the scope of the bibliography; omissions have of course been indicated. The author's name, generally speaking, is given as it appears on the titlepage, amplified and interpreted within square brackets where necessary.

Anonymous bibliographies

Far too large a proportion of bibliographical work is published anonymously. This is due, in part, to the all too common practice of library committees and similar bodies of suppressing altogether or of hiding in prefaces the names of those who have compiled bibliographies and catalogues for them. I have spent a good deal of time in excavating such and other evidences of authorship, and the result may be seen in the large number of titles preceded by names enclosed within square brackets.

Th. B.

Art.

I

1. *Periodicals*

PAN AMERICAN magazines relating to architecture, art and music. Pan american union:

Columbus memorial library: Washington 1942.
ff.[i].13. [100.]*

C[ARLEMILIA] FANFANI and F[RANCESCA] ROSELLI,
Catalogo dei periodici della biblioteca dell' Isti-
tuto nazionale di archeologia e storia dell' arte.
Roma 1947. pp.70. [1250.]

JÓZEF GEBCZAK and STANISŁAW STRAUSS, Biblio-
teka Muzeum śląskiego. Informator i wykaz
czasopism i wydawnictw ciągłych. Muzeum
ślaskie: Wrocław 1953. pp.69. [811.]

ПЕРИОДИЧЕСКАЯ печать СССР, 1917-1949.
Библиографический указатель. Журналы,
труды и бюллетени по языкознанию, лите-
ратуроведению, художественной литерату-
ре и искусству. Всесоюзная книжная пала-
та: Москва 1958. pp.219. [2071.]

GUSTAVE LEBEL, Bibliographie des revues et
périodiques d'art parus en France de 1746 à 1914.
1960. pp.65. [500.]

2. *History*

CARL BERNARD STARK, Handbuch der archäo-
logie der kunst. . . . Erste abtheilung. Systematik
und geschichte der archäologie der kunst. Leipzig
[1878-]1880. pp.viii.400. [2500.]

Art

A LIST of books and pamphlets in the National art library . . . containing biographies of artists and of others connected with the history of art. South Kensington museum [*afterwards:* Victoria and Albert museum]. 1887. pp.[v].261. [4000.]

ANCIENT and classic art. Anna Ticknor library association: [*s.l.* 1897]. ff.8. [125.]

ANNE SEYMOUR AMES and ELIZABETH PARKHILL ANDREWS, Reading lists on renaissance art of the 15th and 16th centuries. University of the state of New York: State library bulletin (Bibliography no.10): [Albany] 1898. pp.209–271. [450.]

CATALOGUE of books. Collection of Thomas Fortune Ryan. New York 1913. pp.49. [700.]

JULIUS VON SCHLOSSER, Materialien zur quellen-kunde der kunstgeschichte. Kaiserliche akademie der wissenschaften: Sitzungsberichte: Philoso-phisch-historische klasse (vol.clxxvii, no.3): 1914.
 i. Mittelalter . . . (vol.clxxvii &c.): Wien.
 pp.102. [500.]
 ii. Frührenaissance . . . (vol.clxxix, no.3):
 1915. pp.72. [300.]
 iii. Erste hälfte des cinquecento: Leonardos
 vermächtnis — historik und periegese . . .
 (vol.clxxx, no.5): 1916. pp.76. [300.]
 iv. Die kunsttheorie der ersten hälfte des

4

cinquecento . . . (vol.clxxxiv, no.2): 1917.
pp.76. [100.]

v. Vasari . . . (vol.clxxxix, no.2): 1918. pp.75.
[150.]

vi. Die kunstliteratur des manierismus . . .
(vol.cxcii, no.2): 1919. pp.137. [400.]

vii. Die geschichtschreibung des barocks und
des klassizismus . . . (vol.cxcv, no.3): 1920.
pp.79. [500.]

viii. Die italienische ortsliteratur . . . (vol.
cxcv, no.5): 1920. pp.112. [750.]

ix. Die kunstlehre des 17. und 18. jahr-
hunderts . . . (vol.cxcvi, no.2): 1920.
pp.114. [500.]

x. Register (zugleich gesamtbibliographie)
und inhaltsübersicht . . . (vol.cxcvi, no.5):
1920. pp.56.

— — La letteratura artistica. . . . Edizione . . .
accresciuta dall' autore. Traduzione italiana di
Filippo Rossi. Firenze [1935]. pp.x.649. [5000.]

— — — Appendice di Otto Kurz. [1938].
pp.40. [300.]

KRITISCHE berichte zur kunstgeschichtlichen
literatur. Leipzig.

i–ii. 1927–1929. Edited by Friedrich Antal
and Bruno Fürst. pp.[iv].256. [25.]

iii–iv. 1930–1932. pp.iv.252. [25.]

v. 1932–1933. pp.132. [10.]

no more published until 1937, when publication was resumed.

GIUSEPPE DELOGU, Essai d'une bibliographie internationale d'histoire de l'art, 1934–1935. Istituto italiano d'arti grafiche: Bergamo 1936. pp.[iv].176. [3000.]

OTTO LEHMANN-BROCKHAUS, Schriftquellen zur kunstgeschichte des 11. und 12. jahrhunderts für Deutschland, Lothringen und Italien. Berlin 1938. pp.xiii.726+[v].343. [3062.]

ANNUARIO bibliografico di storia dell'arte. Istituto nazionale d'archeologia e storia dell'arte: Biblioteca: Modena.

 i. 1952. A cura di Maria Luisa Garroni. 1954. pp.311. [2202.]

 ii. 1953. 1955. pp.379. [2743.]

 iii. 1954. 1956. pp.487. [3373.]

 iv. 1955. 1957. pp.544. [4028.]

 v–vi. 1956–1957. 1960. pp.987. [7655.]

in progress.

PAUL ORTWIN RAVE and BARBARA STEIN, Kunstgeschichte in festschriften. Allgemeine bibliographie kunstwissenschaftlicher abhandlungen in den

bis 1960 erschienenen festschriften. Berlin 1962.
pp.314. [5865.]

3. *Fine arts*

[CHRISTIAN] FRIEDRICH VON BLANKENBURG,
Litterarische zusätze zu Johann George Salzers
Allgemeiner theorie der schönen künste. Leipzig
1796–1798. pp.[iv].651 + [ii].578 + [ii].518.
[20,000.]

JOHANN SAMUEL ERSCH, Handbuch der deut-
schen literatur seit der mitte des achtzehnten
jahrhunderts. Des zweyten bandes dritte . . .
abtheilung, die literatur der schönen künste ent-
haltend. Amsterdam &c. 1814. pp.[ii].coll.544.
[5000.]

— — Literatur der schönen künste. . . . Neue
. . . ausgabe, von Johann Karl August Rese und
Christian Anton Geissler. 1840. pp.[viii].coll.1608.
[15,000.]

CATALOGO ragionato dei libri d'arte e d'anti-
chità posseduti dal conte [Leopoldo] Cicognara.
Pisa 1821. pp.xi.415+[iii].333.lxxviii. [art: 2474.]
this collection is now in the Vatican library.

JULES GODDÉ, Catalogue raisonné d'une collec-
tion de livres, pièces et documents . . . relatifs aux
arts de peinture, sculpture, gravure et architec-

7

ture . . . réunie par m. Jules Goddé. 1850.
pp.[iii].xvi.400. [1650.]

RALPH N[ICHOLSON] WORNUM, An account of
the library of the division of art at Marlborough
house: with a catalogue of the principal works.
Department of science and art: 1855. pp.240.
[3500.]

[SIR WILLIAM STIRLING-MAXWELL], An essay
towards a collection of books relating to the arts
of design, being a catalogue of those at Keir.
1860. pp.[iii].144. [1750.]
 25 copies privately printed.

[JOHN HUNGERFORD POLLEN, *the elder*], Univer-
sal catalogue of books on art: comprehending
painting, sculpture, architecture, decoration,
coins, antiquities, &c. Notes and queries (4 January.
1868-9 April 1870: supplements): 1868-1870.
pp.iv.2211. [60,000.]
 — — [another edition.] The first proofs of the
universal catalogue of books on art. Committee
of [Privy] council on education: 1870. pp.xi.1030
+[iv].1061-2188. [60,000.]
 the two volumes were apparently printed indepen-
dently; the last page of vol.i is numbered 1030-1060.
 — — Supplement. 1877. pp.[iv].656. [20,000.]

GEORGES [GRATET-] DUPLESSIS, Essai d'une bibliographie générale des beaux-arts. 1866. pp.[iv].144. [3209.]

a bibliography of biographies &c. of artists.

LIST of books on art purchased under the directions of the will of the late Felix Slade. Athenaeum [club]: 1870. pp.7. [30.]

[GEORGE M. GREEN], Catalogue of the Eastlake library in the National gallery. 1872. pp.168. [2500.]

ERNEST VINET, Catalogue méthodique de la bibliothèque de l'École nationale des beaux-arts. 1873. pp.xv.256. [2500.]

ERNEST VINET, Bibliographie méthodique et raisonnée des beaux-arts. 1874 [–1878]. pp.xii.vii. 288. [2362.]

incomplete; no more published.

[CARL FRIEDRICH ADOLF VON LÜTZOW], Katalog der bibliothek der K. k. akademie der bildenden künste. Wien 1876. pp.xxii.503. [6000.]

GASTON LAVALLEY, Catalogue des ouvrages relatifs aux beaux-arts qui se trouvent à la Bibliothèque municipale. Caen 1876. pp.158. [1223.]

[HENRY RICHARD TEDDER], Catalogue of books

in the library of the Royal academy of arts. 1877.
pp.viii.314. [4000.]

[—] — A catalogue of books added ... between
1877 and 1900. [By William Frederick Yeames].
1901. pp.[ii].198. [1400.]

JOHN HUTCHISON, Catalogue of the library.
Royal scottish academy: Edinburgh 1878. pp.[iv].
100.

ROBERT LENOX KENNEDY, A classified catalogue
with critical notes on the works on art in the green
alcove of the New York society library. New
York 1879. pp.48. [200.]

GEORGES [GRATET–] DUPLESSIS, Catalogue de la
collection des pièces sur les beaux-arts, imprimées
et manuscrites, . . . acquise récemment par le
Département des estampes de la Bibliothèque
nationale. 1881. pp.[iii].224. [2069.]

VERZEICHNISS der besten schriften über kunst-
literatur, malerei, sculptur, archäologie u. archi-
tektonic welche von 1866–1881 im deutschen
buchhandel erschienen sind. Gracklauer's fach-
katalog (nos.12–13, 34): Leipzig 1881. pp.iv.62+
iv.38+[iii].44. [1500.]

KATALOG der bibliothek. Erste abtheilung:

bücher. 1 heft. Kunstgewerbe–museum: Berlin 1884. pp.64. [750.]
no more published.

FINE arts. Public libraries: Class list (no.4): Nottingham 1884. pp.23. [750.]
— Supplement . . . by J[ohn] Potter Briscoe. 1890. pp.12. [400.]

WILLIAM KENRICK, On some art books in the Reference library. Birmingham reference library: Lectures (no.6): [1886]. pp.26.vi. [200.]

LIST of books in the library of the Burlington fine arts club. 1887. pp.48. [1750.]

BOOKS [*now:* Victoria and Albert museum library accessions]. National art library [*afterwards:* Victoria and Albert museum]. 1890 &c.
this publication has appeared in printed form and reproduced from typewriting, for some time on one side of the leaf, at irregular intervals, and in varying format; in progress.

E. DOBBERT and W. GROHMANN, Katalog der bibliothek der Königlichen akademie der künste zu Berlin. 1893. pp.xxxi.576. [5500.]

каталогъ библиотеки Музея древностей. Императорскій С.-Петербургскій универси-

тетъ. С.-Петербургъ 1896. pp.iv.212. [2000.]

GUSTAV PAULI, Katalog der bibliothek der Koeniglichen akademie der bildenden künste zu Dresden. 1897. pp.xv.299. [3000.]

RUSSELL STURGIS [*and others*], Annotated bibliography of fine art. American library association: Annotated lists: Boston 1897. pp.v.89. [art: 750.]

T[HOMAS] A[RTHUR] ONIONS, Catalogue of books on the fine arts. Public libraries: Newcastle-upon-Tyne 1900. pp.[vi].146. [7500.]

[EDMOND LECHEVALLIER-CHEVIGNARD], Catalogue de la bibliothèque d'art de Georges [Gratet-] Duplessis. Lille [printed] 1900. pp.xvi.266. [7500.]

A HANDBOOK of the [Samuel] P[utman] Avery collection of prints and art books in the New York public library. [New York] 1901. pp.84. [300.]

INTERNATIONALE bibliographie der kunstwissenschaft. Berlin.
> i. 1902. Herausgegeben von Arthur L. Jellinek. 1903. pp.x.368. [5524.]
> ii. 1903. 1904. pp.[viii].376. [5642.]
> iii. 1904. 1907. pp.[iv].368. [5490.]
> iv. 1905. Herausgegeben von Otto Fröhlich.

1908. pp.ix.434. [6579.]

v. 1906. 1909. pp.viii.400. [6164.]

vi–vii. 1907–1908. 1911. pp.viii.308+[iii].
309–634. [11,435.]

viii. 1909. 1913. pp.vii.334. [6619.]

ix. 1910. Herausgegeben von Ignaz Beth.
1913. pp.vii.270. [5995.]

x. 1911. 1914. pp.vii.270. [5829.]

xi. 1912. 1915. pp.viii.300. [6003.]

xii. 1913. 1915. pp.viii.312. [6174.]

xiii. 1914. 1916. pp.viii.260. [5479.]

xiv. 1915–1916. 1918. pp.viii.286. [5475.]

xv. 1917–1918. Herausgegeben von Fritz
Goldschmidt. 1920. pp.viii.250. [5058.]

no more published.

GUSTAVE LAGYE, Catalogue annoté de la biblio-
thèque artistique & littéraire. Académie royale
des beaux-arts: Bruxelles 1903. pp.1170. [3478.]

CATALOGUE de la bibliothèque de l'École des
beaux-arts. Ville de Lille: Lille [printed] 1903.
pp.32. [800.]

KUNSTGESCHICHTLICHE anzeigen. Institut für
österreichische geschichtsforschung: Mitteilun-
gen: Beiblatt: Innsbruck.

i. Redigirt von Franz Wickhoff. 1904.
pp.[iv].130. [35.]

ii. 1905. pp.[iii].128. [35.]
iii. 1906. pp.[iii].130. [35.]
iv. 1907. pp.122. [35.]
[v]. 1909. Redigiert von Max Dvořak.
pp.[iv].132. [30.]
[vi]. 1910. pp.[iv].125. [40.]
[vii]. 1911. pp.[iv].128. [25.]
[viii]. 1912. pp.[iv].123. [30.]
not published in 1908.

CATALOGUS van schoone kunsten en kunst-
nijverheid. Koninklijke bibliotheek: 's-Graven-
hage 1905. pp.[ii].986. [7480.]

BOOKS useful to art students in the National
library. Science and art museum: Dublin 1905.
pp.26. [500.]

HENRY E. CURRAN and CHARLES ROBERTSON, Ex
bibliotheca Hugh Frederick Hornby. Catalogue
of the art library bequeathed by Hugh Frederick
Hornby. Public library: Liverpool 1906. pp.[ix].
648. [5000.]

A[LFRED] HAGELSTANGE, Führer durch die
bücherei des Kaisers Friedrich museums der stadt
Magdeburg. Magdeburg 1906. pp.[iv].330.
[2000.]

FINE ARTS. Eighth edition. Finding lists of the

Chicago public library: Chicago 1907. pp.[iv]. 833–940. [7500.]

CATÁLOGO de la biblioteca de bellas artes plásticas de Antonio Cánovas [del Castillo y Uallejo]. Madrid [1907]. pp.243. [1100.]
150 copies privately printed.

E. R. NORRIS MATHEWS, Fine arts section. Municipal public libraries: Reference library catalogue: Bristol 1909. pp.vi.129. [2000.]

ZENTRALBLATT für kunstwissenschaftliche literatur und bibliographie. 1. Jahrgang (heft 1–10). Leipzig 1909. pp.iv.347. [5000.]
no more published.

ÉTIENNE DEVILLE, Index du Mercure de France, 1672–1832, donnant l'indication . . . de toutes les notices, mentions, annonces, planches, &c., concernant les beaux-arts et l'archéologie. Publications pour faciliter les études d'art en France: 1910. pp.iii–xl.269. [12,500.]
350 copies printed.

RÉPERTOIRE d'art et d'archéologie. Dépouillement des périodiques [et des catalogues de ventes] français et étrangers. [Bibliographie des ouvrages d'art français et étrangers]. [1914 &c.: Université de Paris: Bibliothèque d'art et d'archéologie].

i. 1910. [Edited by] Marcel Aubert. pp.227.
 [3254.]

ii. 1911. pp.[iii].453. [6534.]

iii. 1912. pp.[iii].579. [8343.]

iv. 1913. 1919. pp.[iii].616. [9423.]

1914–1919. 1921. pp.[iii].437. [8349.]

1920. pp.[iii].231. [5796.]

1921. pp.[iii].203. [5050.]

1922. pp.[iii].200. [5082.]

1923. pp.[iii].176. [4600.]

1924. pp.[iii].187. [4897.]

— Index alphabétique, 1920–1924. [By
 — Descombes]. 1925. pp.[iii].169.

1925. pp.[iii].239. [5653.]

1926. pp.iii–xvi.262. [5318.]

1927. pp.xvi.294. [6036.]

1928. pp.[iv].323. [6797.]

1929. pp.[iv].367. [6967.]

1930. pp.[iv].379. [6910.]

1931. pp.[iv].311. [6078.]

1932. pp.[iv].316. [6096.]

1933. pp.[iv].351. [6876.]

1934. pp.[iv].331. [5880.]

1935. pp.[iv].340. [5869.]

1936. pp.[v].336. [6737.]

1937. pp.[iv].311. [5751.]

1938. pp.[vi].371.

1939-1941. 1945. pp.15.471. [9136.]

1942-1944. 1950. pp.xx.320. [10,328.]

1945-1947. 1951. pp.iii-xxi.350. [11,486.]

1948-1949. Rédigé par [Jeanne] Lucien-Herr.
1953. pp.xxii.399. [12,225.]★

1950-1951. Rédigé par mme Lucien-Herr et
mlle Claude Lauriol. 1954. pp.xxiii.770.
[18,152.]

1952. 1956. pp.xxiii.610. [15,034.]

1953. 1958. pp.xxi.590. [13,045.]

1954. 1957. pp.xix.452. [10,124.]

1955. 1958. pp.xx.441. [10,666.]

1956. 1960. pp.xx.428. [10,651.]

lxi. 1957. 1961. pp.xxiv.565. [11,379.]

lxii. 1958. 1962. pp.xxiii.563. [11,171.]

lxiii. 1959. 1963. pp.xxiii.597. [11,902.]

in progress; sale catalogues are not listed after 1930.

INVENTARIO de una colección de libros de arte
que reune A. C. Madrid 1911. pp.641. [1750.]
100 copies privately printed.

CLASSIFIED list of books on the fine and in-
dustrial arts. Free public libraries: Nottingham
1912. pp.20. [1250.]

ÆSTETIK og kunsthistorie, arkitektur, billed-
huggerkunst, malerei. Kunstindustrimuseets og

Kunst- of haandverkskolens bibliotek: Kristiania
[1912]. pp.[iv].60. [1250.]

CATALOGUE général de la Bibliothèque Forney.
Ville de Paris.
 i. Par Henri Clouzot, Louis Engerand. 1912.
 pp.[iii].8.479. [500.]
 ii. Inventaire sommaire des gravures et docu-
 ments prêtés à domicile. Par H. Clouzot,
 Georges Rémon. 1915. pp.viii.63. [999.]
 iii. Premier supplément. 1919. pp.[iii].144.
 [1500.]

KATALOG der Grossherzoglich badischen hof-
und landesbibliothek. . . . Vierte abteilung.
Fachübersichten 1886 bis 1907. Künste. Karlsruhe
1913. pp.[iv].68. [2000.]

ARTHUR WESTWOOD, Catalogue of the books
in the library at the Assay office, Birmingham.
1914. pp.[ii].309. [2500.]

ROBERT B. HARSCHE, A reader's guide to modern
art. San Francisco [1914]. pp.40. [2500.]

THE ATHENÆUM subject index to periodicals. . . .
Fine arts and archæology.
 [1915]. [1915]. pp.[ii].15. [400.]
 — Second edition. 1916. pp.[ii].33. [1000.]
 1916. 1918. pp.44. [1500.]

[*continued as:*]

The subject index to periodicals. . . . G. Fine arts and archæology. Library association.

1917–1919. 1921. pp.[ii].coll.212. [4000.]
1920. 1923. pp.[ii].coll.105. [2000.]
1921. 1924. pp.[ii].coll.110. [2000.]
1922. 1925. pp.[ii].coll.124. [2500.]

subsequent issues were not published in sections.

CHARLES NOURRIT, Catalogue de la bibliothèque de l'École régionale des beaux-arts de Montpellier. Montpellier 1916. pp.60. [1028.]

MILDRED H. LAWSON, An annotated list of books on the arts for the teacher and student. . . . Revised by Royal B[ailey] Farnum. University of the state of New York: Bulletin (no.633): Albany 1917. pp.5–87. [850.]

H. LAVRSKY, Указатель книг и статей по вопросам искусства. Живопись, скульптура, архитектура. Изданѣ 2. Москва 1919. pp.151. [2500.]

MAURICE TOURNEUX, Salons et expositions d'art à Paris (1801–1870). Essai bibliographique. 1919. pp.[iii].195. [3000.]

INDEX of books. Fine art trade guild library: [?1920]. pp.22. [175.]

— Supplementary list. single leaf [1922]. [40.]

FIRST list of selected books on art. Public library: Middlesborough 1921. pp.18. [400.]

[MARCEL ROUX], Catalogue des ouvrages relatifs aux beaux-arts du Cabinet des estampes de la Bibliothèque nationale (série Y). Société de l'histoire de l'art français: Archives de l'art français (n.s., vols.xi &c.): 1921 &c.

in progress.

CATALOGUE of books on architecture and the fine arts in the Gordon Home Blackader library and in the McGill university library. McGill university: Publications (7th ser., no.4): Montreal 1922. pp.3.–65. [2000.]

— — Second . . . edition. A catalogue of books on art and architecture [&c.]. 1926. pp.[ii].193. [4000.]

RUDOLF RIGGENBACH, Katalog der bibliothek des Basler kunstvereins. Basel 1922. pp.xvi.138.

O[SKAR] E[DUARDOVICH] VOLTSENBURG, Библиография изобразительного искусства... Часть 1. Отдельные издания. Выпуск 1-й. Общая теория искусства [2-й. Общая история искусства. Археология искусства]. Петербург 1923. pp.88+188. [794.]

limited to works in russian; no more published?

WALTER TIMMLING, Kunstgeschichte und kunst-
wissenschaft. Kleine literaturführer (vol.vi):
Leipzig 1923. pp.303. [2000.]

— — Nachtrag. Die kunstliteratur der neuesten
zeit. 1928. pp.124. [1000.]

JULIUS SCHLOSSER, Die kunstliteratur. Ein hand-
buch zur quellenkunde der neueren kunst-
geschichte. Wien 1924. pp.iii–xvi.640. [2500.]

JULIUS ZEITLER and ARTHUR LUTHER, Kunst-
wissenschaft. Jahresberichte des Literarischen
zentralblattes über die wichtigsten wissenschaft-
lichen neuerscheinungen des gesamten deutschen
Sprachgebietes (1924, vol.xiv): Leipzig 1925.
pp.138. [750.]

LUCY D. TUCKERMAN, Suggestions for the
library of a small museum of art. . . . A list based
on the library of the Worcester [Mass.] art
museum. American association of museums:
Publications (n.s., no.vi): Washington 1928. pp.
39. [1750.]

MINNIE EARL SEARS, Standard catalog for public
libraries. Fine arts section. . . . Including books
on costume and amusements. Standard catalog
series: New York 1928. pp.xii.191. [1200.]

— — First supplement. 1929. pp.viii.24. [200.]
no more published.

A CLASSIFIED list of new & forthcoming books on fine arts. [National book council:] Readers' guides (no.7).

 1928. pp.12+12. [125.]
 1929. pp.12+8+12+8. [150.]
 1930. pp.8+8+8+8. [100.]
 1931. pp.8+8+12+8. [125.]
 1932. pp.8+8+8. [100.]
 1933. pp.8. [20.]
 1934. pp.8. [35.]
no more published.

JOHN WARNER, Class list of books on the fine arts. Public libraries: Subject lists (no.5): Newport [Mon.] 1929. pp.71. [1750.]

ART and art appreciation. A selected list of books. New . . . edition. National book council: Bibliography (no.73): 1929. pp.[8]. [300.]

— Third edition. By Alec Clifton-Taylor. 1941. pp.12. [350.]

GENERAL reference material on the fine arts. Cincinnati museum library: Book list (no.5): Cincinnati 1929. pp.8. [75.]

[E. COCKERLYNE], A catalogue of books on fine arts, sports and pastimes . . . in the Lancashire county library. Preston 1930. pp.[iv].135. [art: 1000.]

Art

THE ART index. . . . Author and subject index to a selected list of fine arts periodicals and museum bulletins. New York.

1929–1932. Edited by Alice M[aria] Dougan and Bertha Joel. pp.xiii.1565. [30,000.]

1932–1935. pp.xii.1364. [27,500.]

1935–1938. Edited by Sarah St. John and Margaret Furlong. pp.xii.1490. [30,000.]

1938–1941. pp.xii.1297. [27,500.]

1942–1943. pp.vii.360. [7000.]

1944–1945. Edited by Beatrice B. Rakestraw and M. Furlong. pp.ix.377. [7000.]

1945–1946. pp.viii.486. [10,000.]

1944–1947. pp.xiii.1217. [25,000.]

1947–1948. pp.viii.504. [10,000.]

1948–1949. pp.viii.570. [11,000.]

1947–1950. Edited by M. Furlong. pp.xiv.1369. [50,000.]

1950–1953. Edited by M. Furlong and Jeanne C. Des Marais. pp.xiii.1349. [50,000.]

1953–1955. pp.xi.941. [45,000.]

1955–1957. pp.x.960. [45,000.]

1957–1959. Edited by M. Furlong and Mary M. Schmidt. pp.ix.829. [40,000.]

1959–1961. pp.xi.995. [50,000.]

1961–1962. pp.x.506. [25,000.]

in progress; issued monthly, afterwards quarterly, cumulated annually, and as above.

ART books. Public libraries: Fulham 1933. pp.7. [200.]

[EDWARD PEARSON], Fine arts catalogue. Public libraries: Newcastle-upon-Tyne 1934. pp.viii.226. [4500.]

PRISCILLA HISS and ROBERTA FANSLER, Research in fine arts in the colleges & universities of the United States. Carnegie corporation: New York 1934. pp.vii.224. [215.]

CATALOGUS der kunsthistorische bibliothek in het Rijksmuseum. Amsterdam 1934–1936. pp. xiv.709+xix.799+xviii.947+[iii].281. [20,000.]

E[DNA] LOUISE LUCAS, Books on art. A foundation list. Harvard university: Fogg museum of art: Cambridge 1936. pp.[viii].83. [3000.]
— — [another edition]. The Harvard list of books on art. 1952. pp.vii.163. [2500.]

ART appreciation. Books in the Bristol public libraries. [Bristol 1935]. pp.8. [150.]

[REGINALD ARTHUR RYE], Catalogue of books on archæology and art and cognate works belonging to the Preedy memorial library and other collec-

tions in the university library. University of London: [1935–]1937. pp.[v].xviii.438. [10,000.]

[—] — Supplement. 1937. pp.28. [750.]

CATALOGUE of books on art, architecture, sculpture, drawing and design, painting and engraving. County library: Northampton 1937. pp.27. [750.]

A SHORT list of books on the fine arts, with annotations. Metropolitan museum of art: New York 1937. pp.v.50. [150.]

ILLUSTRATED catalogue of publications of the national collections. . . . Part I. Art subjects. Board of education: 1938. pp.xi.82. [250.]

READERS' guide to books on graphic arts. Library association: County libraries section [no.13]: 1938. pp.[i].15. [300.]

N[ICOL]AS GUSTIN, Catalogue du Département des beaux-arts. Bibliothèque communale: Verviers 1939. pp.3–70. [2000.]

ALEC CLIFTON-TAYLOR, Art & art appreciation. National book league: Book list (no.73): Cambridge.

— — [another edition]. [By Peter and Lind Murray]. . . . (2nd ser.): [1950]. pp.31. [400.]

ANTONIO CAETANO DIAS, Catálogo das obras
raras ou valiosas da biblioteca da Escola nacional
de belas artes. Rio de Janeiro 1945. pp.vii.67. [84.]

A[RTHUR] R[AYMOND] YOUNG, Art bibliography.
[New York] 1941. ff.[v].78. [1500.]*
———— [another edition]. 1947. pp.92. [2000.]

LITTERATUR om kunst. Kommunebiblioteker:
København 1948. pp.184. [2500.]

[ELEONORE DE LA FONTAINE VERWEY], Aan-
winsten op het gebied van de beeldende kunsten
gedurende het tijdvak 1940–1948. Koninklijke
bibliotheek: 's Gravenhage 1949. pp.xii.348.
[3000.]

ART reference books. New York state college
of ceramics: Publication (no.4): Alfred, N.Y.
1950. ff.[70.] [1000.]*

PAINTING, drawing and sculpture. A brief read-
ing list. Polytechnic: 1950. pp.[4]. [100.]

E[DNA] LOUISE LUCAS, The Harvard list of
books on art. Cambridge, Mass. 1952. pp.vi.163.
[2500.]

BØKER om kunst, kunsthåndverk og arkitektur i
Rjukan off. bibliotek. Rjukan 1953. ff.[iii].62.
[750.]*

CATÁLOGO de la Exposición del libro español de arte, Barcelona, 1953. Instituto nacional del libro español: Madrid 1953. pp.3–71. [600.]*

CATÁLOGO de la biblioteca y hemeroteca. Museo de arte contemporáneo: Madrid 1954. pp.133. [250.]

[ELEAZAR MOISEEVICH MELETINSKY and N. I. POZHARSKY], Сводный каталог новых иностранных книг по искусствоведению, поступивших в крупнейшие библиотеки СССР в 1949—1953 гг. Всесоюзная государственная библиотека иностранной литературы: Москва 1956. pp.416+439. [10,284.]

GRETE HESSE, Moderne kunst. Bücherverzeichnis zur malerei und plastik vom ausgang des 19. jahrhunderts bis zur gegenwart. Berliner zentralbibliothek: Amerika-gedenkbibliothek: [Berlin ? 1956]. pp.64. [600.]

[FERNANDO VALLERINI], Première exposition du livre italien d'art et d'amateur. Entretiens culturels franco-italiens: 1956. pp.viii.64. [400.]

[I. KLOET], Library of modern art. Catalogus. Stedelijk museum: Bibliotheek: Amsterdam [1957]. pp.179. [2600.]

KATALOG, kunst und kunstgewerbe. Speyer &c.
1958. pp.[vi].468+[vi].469–916.lxxxvi. [9720.]*
*a catalogue of the Pfälzische landesbibliothek, Spires,
and the Pfälzische landesgewerbeanstalt, Kaisers-
lautern.*

[ISABEL SEIJO GONZÁLES *and others*], Catálogo de
la biblioteca de arte. Istituto nacional de cultura:
La Habana [1958]. pp.89. [750.]

JOSEF BLEHA, Knihy o výtvarném umění. Uni-
versita: Čteme a studujeme (1958, no.3): Praze
[1958]. pp.68. [503.]

ИСКУССТВО. Анниотированныес писки ли-
тературы. Библиотека СССР им. В. И. Ле-
нина: Москва.
 i. 1958 [Edited by M. E. Zelenina *and others*].
 pp.13.53.19. 14. 6. [700.]
 ii. 1959. pp.6.75. 24. 24. [900.]

MARY W[ALLS] CHAMBERLAIN, Guide to art
reference books. American library association:
Chicago 1959. pp.xiv.418. [2565.]

ALFRED R[OBERT] NEUMANN and DAVID V. ERD-
MAN, Literature and the other arts. A select biblio-
graphy 1952–1958. Public library: New York
1959. pp.39. [837.]

THE PLASTIC arts. Surrey county library: Book list (no.17): [Esher 1959]. pp.[iv].12. [75.]*

JOSEF BLEHA, Bibliografie české výtvarně umělecké literatury, 1918–1958. Bibliografický katalog ČSSR: České knihy: Praze 1960. pp.315. [2500.]

H[ENRY] LEY, A list of books on art, architecture, drawing, painting and sculpture. Public libraries: Nottingham 1960. pp.[vi].81. [1750.]*

CARL O. PODSZUS, Art. A selected annotated art bibliography [New York 1960]. pp.111. [1000.]*

THE INTERNATIONAL guide to literary and art periodicals.
1960. [Edited by Mary Carol Bird.]
1961. pp.[iv].152. [300.]

CATALOG of the Warburg institute library, university of London. Boston 1961. pp.[ix].1002+ [iii].1003–2001. [70,000.]
this is a photographic reproduction of catalogue cards; the figure in square brackets refers to these cards.

E. E. NAIDICH, *ed.* Искусство — всем. Публичная библиотека им. М. Е. Салтыкова-Щедрина: В помощь эстетическому воспитанию: Ленинград 1960. pp.15. [400.]

MOSTRA del libro d'arte italiano [Athens]. Cata-

logo. Ministerio degli affari esteri: [Roma] 1960.
pp.137. [200.]

искусство. Аннотированные списки литературы. Государственная . . . библиотека СССР имени В. И. Ленина: Москва 1960 &c. *in progress.*

[MAURICE CROUSLÉ, *ed.*] L'Art et les artistes. Librairie Hachette: Département étranger: 1961. pp.344. [5000.]

INDEX to art periodicals. Compiled in Ryerson library, the Art institute of Chicago. Boston 1962.
 i. A–Bol. pp.xi.890. [18,667.]
 ii. Bom–Children, pp.[x].891–1767. [18,403.]
 iii. Chile–Duc. pp.[ii].1769–2658. [18,661].
 iv. Dud–Giac. pp.[ii].2659–3543. [18,580.]
 v. Giam–IndiansI. pp.[ii].3545–4441. [18,836.]
 vi. Indians M–Liti. pp.[ii].4443–5316. [18,353]
 vii. Litt–Myo. pp.[ii].5317–6252. [19,636.]
 viii. Myr–Pottery F. pp.[ii].6253–7115. [18,059.]
 ix. Pottery G–Sculpture A. pp.[ii].7117–7977. [18,073.]
 x. Sculpture B–Torre. pp.[ii].7979–8873. [18,788.]
 xi. Toul–Zz. pp.[ii].8875–9635. [15,978.]
this is a photographic reproduction of catalogue cards; the figures in square brackets represent these cards.

JANE CLAPP, Museum publications. Part 1. Anthropology, archaeology and art. New York 1962. pp.434. [4416.]*

FIRST supplement to the dictionary catalog of the library of the Metropolitan museum of art. Boston 1962. pp.[vi].1040. [21,840.]
reproduces the catalogue cards, to which the number in square brackets refers.

4. *Decorative and applied art*
[*see also* **Technology**]

[EDUARD CHMELARZ and FRANZ RITTER], Katalog der bibliothek des K. k. österreichischen museums für kunst und industrie. Wien 1883. pp.xvi.582. [8000.]

H. GROSCH, Katalog over Museets bibliothek og dets samling af mønsterblade. Kunstindustrimuseet: Kristiana 1891. pp.xvi.80. [1600.]

HERBERT BATSFORD, Reference books in architecture & decoration. [1894]. pp.24. [60.]
privately printed.

DECORATION and design. Drexel institute library: Reference lists (no.3): [Philadelphia] 1869. pp.23–38. [300.]

HAND-LIST of books on the decorative arts in the reference department. Public libraries: Liverpool 1899. pp.[iv].113. [1500.]

SUBJECT list of works on photography and the allied arts and sciences in the library of the Patent office. Patent office library series (no.2 = Bibliographical series, no.1): 1900. pp.64. [557.]

— [second edition]. Subject list of works on the fine and graphic arts [including photography], and art industries. 1904. pp.376. [2916.]

LIST of books, &c., relating to ornament and decoration in the library of the museum. Edinburgh museum of science and art: Glasgow 1902. pp.[iv].237. [3250.]

A LIST of books on industrial arts. John Crerar library: Chicago 1904. pp.249. [1625.]

F. A. BOROVSKÝ and ZD. WIRTH, Bücher-katalog. Kunstgewerbliches museum der handels- und gewerbekammer: Prag 1907. pp.xvi.515.lxxvi. [5000.]

OTTO PELKA, Katalog der bibliothek des Städtischen kunstgewerbe-museums. Leipzig 1908. pp.vii.310. [4500.]

— — Schlagwörterbuch. 1908. pp.vi.162.

F. BENTLEY NICHOLSON, Catalogue of books on ceramics, glassware, ornamental metal work, enamels and jade. Public free libraries: Occasional lists (no.8): Manchester 1908. pp.20. [300.]

LIST of references on arts and crafts. Library of Congress: Washington 1908. ff.12. [64.]★
— Additional references. 1918. ff.2 [29.]★

[I. LÁSZLÓ SZŐNYI AND JÓSZEF TANTOSSY], Az Orsz. magyar iparművészeti müzeum és Iskola könyvtárának czímjegyzéke. Országos magyar iparművészeti múzeum: Budapest 1913. pp.iii–xv.858. [6000.]

SUBJECT list of works on the fine and graphic arts (excluding photo-mechanical printing and photography). Patent office library: Subject lists (ns. BM–BZ): 1914. pp.iv.224. [2000.]

MIGUEL VELASCO Y AGUIRE, Obras de ornamentación y de artes industriales existentes en la sección de bellas artes de la Biblioteca nacional. Catálogo provisional. Madrid 1914. pp.[iv].115. [art: 165.]

LIST of references on art industries and trade. Library of Congress [Washington] 1920. ff.9. [92.]★

A CATALOGUE of the art books in the Central

library. Public library: Dunfermline 1924. pp.40. vi. [500.]

FLORENCE N[IGHTINGALE] LEVY, James Parton Haney. A bibliography of his writings on the arts. School art league: New York 1924. pp.12. [150.]

MARION E[LIZABETH] CLARK [*and others*], Art in home economics. A bibliography. University of Chicago home economics series: Chicago [1925]. pp.x.66. [400.]

APPLIED art. A selected list of works. Public library: Brief reading lists (no.39): Boston 1929. pp.56. [2500.]

DESIGN in industry. The industrialist is an artist. Public library: Newark, N.J.

 i. 1930–1931. pp.[100]. [849.]
 ii. 1931–1932. pp.[80]. [567.]
 iii.1932–1933. pp.[32]. [249.]
no more published.

WILLIAM ADAMS SLADE, *ed.* Handicraft. A bibliographical list. Library of Congress: [Washington] 1930. ff.27. [226.]*

—— [another edition]. A selected list of books and pamphlets. Compiled by Helen F[ield]

Conover under the direction of Florence S[elma] Hellman. 1939. pp.37. [430.]*

CATALOGUE. Pennsylvania museum: School of industrial art: Library: [Philadelphia] 1931. pp.3–133. [1300.]

READERS' guide to books on handicrafts. Library association: County libraries section [no.5]: 1937. pp.[iii].24. [700.]
—— [another edition]. Readers' guide to handicrafts. . . . (new series, no.7): 1950. pp.56. [750.]

[ERWIN D. CHRISTENSEN and LOUISE MOORE], Arts and crafts: a bibliography for craftsmen. National gallery of art: Washington 1949. pp.80. [250.]

SELECTED bibliographies on manual industry methods and equipment. International cooperation administration: Office of industrial resources: Small industry series (no.6): Washington [1956]. pp.[ii].54. [500.]*

BIBLIOGRAPHIE des handwerks. Verzeichnis der dissertationen. Universität Göttingen: Seminar für handwerkswesen: Göttingen.*
 1933–1944. Bearbeitet von Marianne Kidery. 1956. ff.147. [953.]

1945–1952. Bearbeitet von Gerhard Kämpf. 1955. ff.[48]. [300.]

MANUAL arts. Pacific air force: PACAF basic bibliographies: [*s.l.*] 1957. pp.[iii].ii.30. [150.]*

HELEN M. THOMPSON, Manual arts and crafts. [Pacific air forces:] PACAF basic bibliographies: San Francisco 1960. pp.[ii].vi.101. [325.]*

ГРАФИКА. Государственная публичная библиотека имени М. Е. Салтыкова–Щедрина: [Leningrad 1961]. pp.16. [40.]

5. *Art sales*

NAAMLIJST van nederlandsche kunst-catalogi . . . vanaf 1731 tot 1861 welke de verzameling uitmaken van A. van der Willigen. Haarlem 1873. *the collection is now in the Bibliothèque nationale.*

[LOUIS SOULLIÉ], Les ventes de tableaux, dessins, estampes et objets d'art aux XVIIᵉ et XVIIIᵉ siècles (1611–1800). Essai de bibliographie. 1874. pp.[iii].iv.122. [2158.]

a copy in the Bibliothèque nationale contains numerous additions in ms. by baron Charles Davillier.

[—] — au XIXᵉ siècle. 1896. pp.xxi.358. [5972.]

FRITS LUGT, Répertoire des catalogues de ventes publiques intéressant l'art et la curiosité. Rijks-

bureau voor kunsthistorische en ikonografische documentatie: Publications: La Haye.

 i. *c.*1600–1825. 1938. pp.[iv].xx.[496]. [11,065.]

 ii. 1826–1860. 1953. pp.xxiii.726. [14,844.]

[ADLORE] HAROLD LANCOUR, American art auction catalogues, 1785–1942. A union list. Public library: New York 1944. pp.377. [7317.]

6. *Countries &c.*

Africa

BARBARA JUNE CRAIG, Rock paintings and petro-glyphs of south and central Africa. Bibliography of prehistoric art. University of Cape Town: School of librarianship: Bibliographical series: [Capetown] 1947. ff.[ii].v.58. [272.]*

—— 1947–1958. By Ingrid Rosenkranz. 1958. pp.[iii].iii.24. [231.]*

DOREEN B. MIRVISH, South african artists, 1900–1958. Bibliography. University of Cape Town: School of librarianship: Bibliographical series: [Capetown] 1959. pp.vii.41. [306.]*

America

BIBLIOGRAPHY of the fine arts in the other american republics. Prepared by Archives of his-

panic culture, Hispanic foundation, Library of
Congress, for the Office of the Coordinator of
inter-american affairs. [Washington 1941]. pp.12.
[225.]*

MATILDE LÓPEZ SERRANO, Bibliografía de arte
español y americano. Consejo superior de inves-
tigaciones cientificas: Instituto Diego Velazquez:
Madrid 1942. pp.243. [3507.]

THE FINE and folk arts of the other american
republics. A bibliography of publications in
english. Library of Congress: Hispanic founda-
tion: Washington 1942. pp.[ii].18. [180.]*

JOHN B[ROMMER] MONTIGNANI, Books on latin
America and its art in the Metropolitan museum
of art library. New York 1943. ff.[i].63. [600.]*

EMILIE SANDSTEN LASSALLE, Arts, crafts and
customs of our neighbour republics: a biblio-
graphy. Compiled . . . under the direction of
Nora Beust. Office of education: Library service
division: Bulletin (1942, no.8): Washington 1943.
pp.52. [90.]
 *previously issued in 1942, reproduced from type-
writing, by the Federal security agency.*

ROBERT C[HESTER] SMITH and ELIZABETH WILDER,
A guide to the art of latin America. Library of

Congress: Latin american series (no.21): Washington 1948. pp.[v].480. [4896.]

American indian

LIST of references to writings on pre-columbian art in America. Library of Congress: Washington 1926. ff.21. [255.]★

RUTH [LOUISE] GAINES, Books on indian arts north of Mexico. Exposition of indian tribal arts. New York 1931. pp.15. [600.]

KENNETH M[ILTON] CHAPMAN, Decorative art of the Indians of the Southwest. A list of publications containing illustrations . . . of especial value in the study of design. Laboratory of anthropology: General series (no.1): Santa Fé 1931. ff.[i].7. [82.]★

ANNE [DIMSDALE] HARDING and PATRICIA BOLLING, Bibliography of articles and papers on north american indian art. Indian arts and crafts board: Washington [1938]. pp.[x].365. [1500.]★

Argentina

MARIO J[OSÉ] BUSCHIAZZO, Bibliografía de arte colonial argentino. [Universidad de Buenos Aires: Instituto de arte americano e investigaciones esteticas:] Buenos Aires 1947. pp.vii. [*sic*, xii].151. [843.]

Art

Baltic

NIELS VON HOLST, Die deutsche kunst des Balten-
landes im lichte neuer forschung. Bericht über das
gesamte schrifttum seit dem weltkrieg (1919–
1939). [Deutsche akademie: Schriften (no.31):]
München 1942. pp.160. [316.]

Belgium, see Netherlands

Brazil

ARTE brasileira. . . . Bibliografía comentada.
Centro de estudios bahianos: Publicação (no.30):
Salvador.

 1943–1953. [By] José Valladeres. 1955. pp.
 [ii].viii.79. [506.]
 1954. 1958. pp.3–46. [151.]

JOSÉ VALLADARES, Estudos de arte brasileira.
Publicações de 1943–1958. Bibliografia seletiva e
comentada. Museu do estado da Bahia: Publicação
(no.15): Salvador 1960. pp.xvii.193. [693.]

Byzantine and (early) christian

OSCAR [KONSTANTIN] WULFF, Bibliographisch-
kritischer nachtrag zu altchristliche und byzan-
tinische kunst. Handbuch der kunstwissenschaft:
Potsdam [1939]. pp.[iii].88. [500.]

Art

China

CHINESE art. Far eastern book and journal lists (no.11): Public library: Newark, N.J. [1921]. single leaf. [19.]

CHINESE art. National book council. Book list (no.146): 1935. pp.15. [250.]

Colombia

GABRIEL GIRALDO JARAMILLO, Bibliografía selecta del arte en Colombia. Biblioteca di bibliografía colombiana (no.1): Bogotá 1955. pp.146. [500.]

Congo

THÉODORE HEYSE, Bibliographie du Congo belge et du Ruanda-Urundi (1939–1949). Beaux-arts, urbanisme, arts indigènes, cinéma. Cahiers belges et congolais (no.11): Bruxelles 1950. pp.45. [529.]

Czechoslovakia

JOSEF BLEHA, Soupis české literatury o výtvarném umění, 1945–1954. Universita: Čteme a studujeme (1956, no.1): Praha 1956. pp.180. [2321.]

Denmark

MERETE BODELSEN and AAGE MARCUS, Dansk

kunśthistorisk bibliografi. København 1935. pp.503. [7500.]

Europe

LITERATUR unserer bibliothek zur themengruppe bildende und darstellende kunst, musik im sowjet-kommunistischen einflussbereich. Gesamteuropäisches studienwerk: Bibliothek: Auswahlverzeichnis (no.xii): Vlotho 1958. ff.[ii].86 [750.]*

T. G. ROSENTHAL, European art history. National book league: Reader's guides (4th ser., no.4): Cambridge 1960. pp.32. [125.]

France

ULYSSE ROBERT, Quittances de peintres, sculpteurs et architectes français, 1535–1711, . . . de la collection des quittances provenant de la Chambre des comptes. [1875]. pp.82. [252.]

15 copies printed.

EUGÈNE MÜNTZ, Catalogue des manuscrits de la bibliothèque de l'École des beaux-arts. 1895. pp. 26. [419.]

LUCIEN LAZARD, Inventaire alphabétique des documents relatifs aux artistes parisiens conservés aux archives de la Seine. 1906. pp.46. [650.]

GABRIEL ROUCHÉS, Documents figurant au fonds

d'archives de la bibliothèque de l'École des beaux-arts, et intéressant l'histoire de l'art français aux XVII^e et XVIII^e siècles. 1913. pp.16. [150.]

VISCOUNT CHARLES DU PELOUX, Répertoire biographique et bibliographique des artistes du XVIII^e siècle français. 1930. pp.viii.456. [3500.]

RÉPERTOIRE des publications de la Société de l'histoire de l'art français.

> 1851–1927. Par [Alphonse] J[ean] J[oseph] Marquet de Vasselot. 1930. pp.ii.xxxii.219. [5000.]
>
> 1928–1956. Par J. J. Marquet de Vasselot [and Roger Armand Weigert]. 1958. pp.viii. 131. [1000.]

J. G. MANN, French art. National book council: Book list (no.133): 1931. pp.[4]. [125.]

FRENCH art. A hand-list of books on french art in the Wigan central library. Wigan 1932. pp.8. [250.]

FRENCH art. Books in the Bristol public libraries. [Bristol 1932]. pp.16. [200.]

MIREILLE RAMBAUD, GEORGES BAILHACHE and MICHEL FLEURY, Les sources de l'histoire de l'art aux Archives nationales ... avec une étude sur les sources de l'histoire de l'art aux Archives de la

Seine. Direction des archives: 1955. pp.173. [very large number.]

LOUIS FERRAND and EDMOND MAGNAC, Guide bibliographique de l'imagerie populaire. [1956]. pp.285–326. [525.]

[GEORGES WILDENSTEIN], Les sources d'information sur les artistes provinciaux français. Gazette des beaux-arts: [1958]. pp.94–104. [150.]

Germany

HERMANN SEPP, Bibliographie der bayerischen kunstgeschichte. Studien zur deutschen kunstgeschichte (no.67): Strassburg 1906. pp.ix.346. [4000.]
—— Nachtrag . . . (no.155): 1912. pp.x.208. [2500.]

HERBERT GRUHN, Bibliographie der schlesischen kunstgeschichte. Historische kommission für Schlesien: Schlesische bibliographie (vol.vi.1): Breslau 1933. pp.xv.357. [4305.]

SCHRIFTTUM zur deutschen kunst. Deutscher verein für kunstwissenschaft: Berlin.
 i. 1933–1934. Zusammengestellt von Hans Kauffmann. pp.[vi].58. [1750.]

ii. 1934–1935. pp.[vi].123. [4000.]

iii. 1935–1936. Fortgesetzt von Heinrich Appel. pp.[vii].108. [4000.]

iv. 1936–1937. pp.[vii].122. [5000.]

v. 1937–1938. Bearbeitet von Wolf Maurenbrecher. pp.[vii].94. [3271.]

vi. 1938–1939. pp.[vii].147. [4453.]

vii. 1939–1940. Bearbeitet von Ewald Behrens. pp.[vii].134. [4515.]

viii. 1940–1941. Zusammengestellt von Angela Wirtz-Pudelko. pp.[vii].103. [3296.]

ix. 1941–1942.

x. 1942–1943. Zusammengestellt von Angela Wirtz-Pudelko. pp.[vii].69. [2071.]

xi. 1943–1945. pp.140. [4484.]

xii. 1945–1948. 1951. pp.[vii].125. [4239.]

xiii. 1949. Mit nachträgen aus dem vorhergehenden jahrzehnt. 1954. pp.[vii].131. [4092.]

xiv–xv. 1950–1951. Zusammengestellt von Eberhard Marx und Elisabeth Rücker. 1957. pp.[vii].199. [6406.]

xvi–xvii. 1952–1953. 1958. pp.[vii].186. [5864.]

xviii–xix. 1954–1955. 1959. pp.[vii].187. [5747.]

xx–xxi. 1956–1957. Zusammengestellt von

Dorothee Lauffs, Helmut Nickel. 1961.
pp.[iv].211. [6082.]

in progress.

GISELA KRIENKE, Bibliographie zu kunst und
kunstgeschichte. Veröffentlichungen im gebiet
der Deutschen Demokratischen Republik 1945–
1953. Karl-Marx-universität: Kunsthistorisches
institut: Leipzig 1956. pp.xii.284. [5075.]

WALTER HENTSCHEL, Bibliographie zur sächsi-
schen kunstgeschichte. Deutsche akademie der
wissenschaften zu Berlin: Arbeitsstelle für kunst-
geschichte: Schriften zur kunstgeschichte (no.4):
Berlin 1960. pp.x.273. [7376.]

SCHRIFTTUM zur deutschen kunst des 20. jahr-
hunderts. Eine bibliographie. 2. auflage. Köln.
i. 1960. Bearbeitet von Ernst Thiele. pp.119.
[400.]

in progress.

EDITH NEUBAUER and GERDA SCHLEGELMILCH,
Bibliographie zur brandenburgischen kunst-
geschichte. Deutsche akademie der wissenschaften
zu Berlin: Schriften zur kunstgeschichte (no.7):
Berlin 1961. pp.xii.231. [5331.]

HANS WICHMANN, Bibliographie der kunst in

Bayern. Bayerische akademie der wissenschaften: Kommission für bayerische landesgeschichte: Bibliographien (vol.i–iv): Wiesbaden 1961– pp.lii.810.6+xvi.757.6. [35,800.]

EDITH FRÜNDT, Bibliographie zur kunstge- schichte von Mecklenburg und Vorpommern. Deutsche akademie der wissenschaften: Schriften zur kunstgeschichte (no.8): Berlin 1962. pp.xxiii. 123. [3648.]

Great Britain

GEO[RGE] A[RTHUR] STEPHEN, Norfolk artists. An annotated catalogue of the books, pamphlets, and articles relating to deceased Norfolk artists in the Norwich public library. Norfolk celebrities (no.ii): Norwich 1915. pp.27. [500.]

BRITISH art. A selected list compiled by the Lecture committee of the Exhibition of british art, Royal academy, 1934. National book council: Book list (no.140): 1933. pp.8. [150.]

— Second edition. By Charles Johnson. 1941. pp.8. [200.]

ANNUAL bibliography of the history of british art. Courtauld institute of art [London]: Cambridge.

 i. 1934. 1936. pp.xv.94. [1067.]
 ii. 1935. 1937. pp.xx.134. [1752.]
 iii. 1936. 1938. pp.xxiii.186. [1771.]

Art

iv. 1937. 1939. pp.xxiii.164. [1496.]
[*continued as:*]
Bibliography of the history of british art.
v. 1938–1945. 1951. pp.xxix.207+209–486.
[5365.]
vi. 1946–1948. 1956. pp.xxix.199+[iv].201–
424. [3974.]

BOOKS on art, architecture and archæology
published during 1936. pp.16. [250.]
limited to works published in Great Britain.

Greece

J[OHANNES ADOLPH] OVERBECK, Die antiken
schriftquellen zur geschichte der bildenden künste
bei den Griechen. Leipzig 1868. pp.xx.488. [2400.]

Hungary

ISTVÁN GENTHON, A magyar művészettörténet
bibliográfiája. Müzeumok és műemlékek orszá-
gos központjának: Bibliográfiai sorozata (vol.i):
Budapest 1950. pp.148. [2434.]

BÉLA BIRÓ, *ed.,* A magyar művészettörténeti
irodalom bibliográfiája. [Budapest] 1955. pp.612.
[30,000.]

India

ANANDA K. COOMARASWAMY [KUMĀRASVĀMI],

48

Bibliographies of indian art. Museum of fine art: Boston 1925. pp.v.54. [1250.]

INDIAN art. Third edition. [National book council]: Book list (no.45): 1931. pp.[4]. [125.]
— Fourth edition. 1941. pp.[2]. [65.]

HARIDAS [HARI-DĀSA] MITRA, Contribution to a bibliography of indian art and aesthetics. Santi-niketan 1951. pp.[v].240. [500.]
limited to sanskrit writings on architecture, sculpture and painting.

Islam

ANNUAL bibliography of islamic art and archæology, India excepted. Jerusalem.
 i. 1935. Edited by L. A. Mayer. 1937. pp.[ix]. 64. [600.]
 ii. 1936. 1938. pp.ix.80. [750.]
 iii. 1937. 1939. pp.[ix].96. [900.]

ISLAMIC art and archaeology. Cambridge.*
 1954. Compiled by J[ames] D[ouglas] Pearson and D. S. Rice. 1956. pp.iii.38. [355.]
 1955. 1960. pp.[ii].iii.65. [478.]
in progress.

HARRIET DYER ADAMS, Selective bibliography of hispano-islamic art in Spain and northern Africa,

711–1492. New York university: [New York 1939]. ff.[iv].79. [1200.]

K[EPPEL] A[RCHIBALD] C[AMERON] CRESWELL, A bibliography of the architecture, arts and crafts of Islam to 1st Jan. 1960. [Cairo] 1961. pp.xxiv.coll. 1330.pp.xxv. [15,000.]

Italy

RASSEGNA bibliografica dell'arte italiana. Edited by Egidio Calzini. Rocca S. Casciano [vols.iii–xix: Ascoli Piceno].

 i. 1898. pp.iv.275. [750.]
 ii. 1899. pp.iv.296. [750.]
 iii. 1900. pp.iv.250. [750.]
 iv. 1901. pp.iv.252.12.8. [750.]
 v. 1902. pp.iv.228. [500.]
 vi. 1903. pp.iv.203.7. [500.]

 vii. 1904. pp.iv.224.8. [500.]
 viii. 1905. pp.iv.224.8. [500.]
 ix. 1906. pp.iv.204.8. [500.]
 x. 1907. pp.iv.188. [500.]
 xi. 1908. pp.iv.220. [500.]
 xii. 1909. pp.iv.184. [500.]
 xiii.1910. pp.iv.176. [500.]
 xiv. 1911. pp.iv.172. [500.]
 xv. 1912. pp.iv.176. [500.]

xvi. 1913. pp.iv.164. [400.]
xvii. 1914. pp.v.180. [500.]
xviii. 1915. pp.iv.164. [400.]
xix. 1916. pp.iv.144. [300.]
no more published.

LIBRI d'arte nella Biblioteca bertoliana di Vicenza. Vicenza 1911. pp.420. [3445.]

ANNUARIO bibliografico di archeologia e di storia dell' arte per l'Italia. Compilato da F. Gatti e F[rancesco] Pellati. Roma.

i. 1911. 1913. pp.xxi.195. [3722.]
ii. 1912. 1914. pp.iii–xx.296. [5354.]
no more published.

GIUSEPPE CECI, Saggio di una bibliografia per la storia delle arti figurative nell' Italia meridionale. Bari 1911. pp.vii.322. [2074.]
—— [another edition]. Bibliografia [&c.]. R. deputazione napoletana di storia patria: Napoli 1937. pp.iii–vii.399+[ii].401–765. [5670.]

JULIUS VON SCHLOSSER, Materialien zur quellenkunde der kunstgeschichte. . . . vii. Die italienische ortsliteratur. Kaiserliche akademie der wissenschaften: Sitzungsberichte: Philosophisch-historische klasse (vol.cxcv, no.5): Wien 1920. pp.112. [750.]

Art

COSTANZA GRADARA PESCI, Bibliografia artistica dell' Abruzzo. Roma 1927. pp.59. [1250.]
this is a bibliography of works of art preserved in the Abruzzi.

FRANCIS J[OSEPH] GECK, Bibliographies of italian art. University of Colorado: Boulder.

> v. Bibliography of italian gothic art. 1935. pp.v.77. [1000.]
>
> vi. Il quattrocento. Bibliography of italian early renaissance art. 1932. pp.36. [400.]
>
> vii. Il cinquecento, prima parte. Bibliography of italian high renaissance art. 1933. pp.v.61. [750.]
>
> viii. Il cinquecento, seconda parte. Bibliography of italian late renaissance art. 1934. pp.v.71. [1000.]
>
> ix. Bibliography of italian baroque art. 1937. pp.73. [1000.]
>
> x. Bibliography of italian rococo art. [1941]. pp.v.76. [750.]

no more published.

ALBERTO DEPPI, Arti figurative (1921–35). Guide bibliografiche italiane: Roma 1935. pp.94.

GIUSEPPE CECI, Bibliografia per la storia delle arti figurative nell' Italia meridionale. R. depu-

tazione napoletana di storia patria: Napoli 1937.
pp.iii–vii.399+[ii].401–765. [5670.]

ANTONIO TARAMELLI, Bibliografia romano-
sarda. Istituto di studi romani: Bibliografie ragio-
nate dell' Italia romana (no.1): Roma 1939. pp.87.
[896.]

SERGIO S. LODOVICI, Storici teorici e critici delle
arti figurative d'Italia dal 1800 al 1940. [Dizionari
biografici e bibliografici Tosi (vol.vi):] Roma
1946. pp.7–413. [20,000.]

UMBERTO CHIERICI, Saggio de bibliografia per la
storia delle arti figurative in Abruzzo. Roma 1947.
pp.220. [1488.]

ERARDO [ERHARD] AESCHLIMAN, Bibliografia del
libro d'arte italiano, 1940–1952. Roma [1952].
pp.xv.380. [3000.]

FABIA BORRONI, 'Il cicognara'. Bibliografia del-
l'archeologia classica e dell'arte italiana. Biblioteca
bibliografica italica (vols.6, 7, 10, 11, 19, 23, 25
&c): Firenze 1954– . pp.3–449+3–444+3–
350+3–264+3–366+3–413+3–414+ .
in progress.

FERDINAND BOYER, L'histoire des beaux arts et de
l'urbanisme dans l'Italie napoléonienne d'après les

ouvrages parus depuis 1900. Livorno [printed] 1955. pp.12. [80.]

AN EXHIBITION of italian art books presented to the people of New Zealand by ... the government of Italy. [Alexander Turnbull library: Wellington 1958]. pp.[31]. [256.]*

G. BOVINI, Principale bibliografia su Ravenna romana, paleocristiana e paleobizantina. Università degli studi di Bologna: Corsi di cultura sull'arte ravennate e bizantina: Ravenna 1959. pp.29. [350.]

Japan

[EDWARD FAIRBROTHER STRANGE], Japanese art. I. Japanese books and albums of prints in colour. [II. Books relating to japanese art] in the National art library. 1893. pp.94+39. [1000.]

JAPANESE art. Public library: Far eastern book and journal lists (no.5): Newark, N.J. [1921]. single leaf. [19.]

BRIEF list of references on japanese art. Library of Congress: Washington 1922. ff.5. [51.]*

Mexico

BIBLIOGRAFÍA de las artes populares plasticas de México. Instituto nacional indigenista: Memorias,

Art

(vol.i, no.2): México 1950. pp.[iv].83–132. [1500.]

MARÍA LUISA OCAMPO and MARÍA MEDIZ BOLIO, Apuntes para una bibliografía del arte en México. Biblioteca enciclopédica popular (no.232): México 1957. pp.195. [1031.]

Negro

SUBJECT index to literature on Negro art. Selected from the union catalog of printed materials on the Negro in the Chicago libraries. Chicago public library omnibus project: Chicago 1941. ff.[vii].52. [400.]*

Netherlands

A. A. VAN RIJNBACH, Repertorium van tijdschriftartikelen betreffende nederlandsche monumenten van geschiedenis en kunst. Leiden [1909]–1922.

details of this work are entered under Archaeology: Netherlands, above.

CATALOGUS van boeken in noord-Nederland vershenen van de vroogsten tijd tot op heden. [VIII. Kunst.] Samengesteld door de Tentoonstellings-commissie der Nationale tentoonstelling van het boek . . . 1910. Vereeniging ter bevordering van de belangen des boekhandels: 's-Gra-

venhage 1911. pp.[ii].coll.158.[xx]. [200.]

J[OHANNES] A[LBERTUS] F[RANCISCUS] ORBAAN
[vols.ii–iii: G. J. HOOGEWERFF], Bescheiden in Italië
omtrent nederlandsche kunstenaars en geleerden.
Rijks geschiedkundige publicatiën (kleine serie,
vol.x &c.): 's-Gravenhage.

 i. Rome. Vaticaansche bibliotheek . . .
 (vol.x): 1911. pp.xxii.438. [2000.]
 ii. Rome. Archieven van bijzondere instel-
 lingen ... (vol.xii): 1913. pp.xv.901. [400.]
 iii. Rome. Overige bibliotheken . . . (vol.
 xvii): 1917. pp.xi.541. [2000.]

THE BIBLIOGRAPHY of the Rijksbureau voor
kunsthistorischedocumentatie[vol.i,no.(4)–:ofthe
Netherlands institute for art history]. The Hague.

 i. 1943[–1945]. ff.[i]. 86. [825.]
 ii. 1946. [By W. M. C. Juynboll]. ff.118.
 [684.]
 iii. 1947. ff.56+66+40. [1005.]
 iv. 1948. ff.87+90+ .
 v. 1949–1950. ff.346. [2240.]
 vi. 1951–1952. ff.368. [2315.]
 vii. 1953–1954. ff.353. [2480.]
 viii. 1955–1956. ff.[ii].406. [2779.]
 ix. 1957–1958. ff.[i].227+
 in progress; limited to dutch and flemish art.

REPERTORIUM betreffende nederlandsche monumenten van geschiedenis en kunst (voornamelijk van tijdschriftartikelen). Nederlandsche oudheidkundige bond: 's-Gravenhage 1901 &c.

details of this work are entered under Archaeology: Netherlands, above.

VLAAMSE kunst. Koninklijke vlaamse academie: Brussel.

 i. 1959. [By] Louis Lebeer.
 ii. 1960. pp.129. [400.]

Oriental

CHARLES ANDRÉ JULIEN, Renseignements bibliographiques et pratiques sur les arts et la civilisation de l'Inde, du Cambodge, de la Chine et du Japon. 1927. pp.19. [150.]

BENJAMIN ROWLAND, Outline and bibliographies of oriental art. Cambridge, Mass. 1938. pp.[ii].ff.3-41. [500.]

—— Revised edition. The Harvard outline and reading lists for oriental art. 1958. pp.[v].74. [1500.]

Persia

HENRY CORBIN [*and others*], Les arts de l'Iran, l'ancienne Perse et Bagdad. Bibliothèque nationale: 1938. pp.x.208. [569.]

Art

Portugal

ARNALDO HENRIQUES DE OLIVEIRA, Bibliografia artística portuguesa. Descrição bibliográfica da biblioteca que pertenceu ao ilustre bibliófilo dr. Luiz Xavier da Costa. Lisboa 1944. pp.[xv].320. [2930.]

Russia

PETR [IVANOVICH] KEPPEN, Списокъ русскимъ памятникамъ, служащимъ составленію исторіи художествъ и отечественной палеографіи. Москва 1822. pp.k.viii.120. [174.]

NIKOLAI I[VANOVICH] MATSUEV, Художественная литература, русская и переводная в оценке критики. Библиографический указатель. Одесса &c.

 i. 1917–1925. pp.171. [2100.]
 ii. 1926–1928.
 iii. 1929–1932.
 iv. 1933–1937.

M. SHCHAKATSIKIN, Беларускае мастацтва ў гістарычнай і архэолёгічнай літературы. Менск 1927. pp.55. [200.]
100 copies printed.

[V. F. RUMYANTSEV and L. V. ROZENTAL], Указатель литературы по истории русской жи-

вописи, скульптуры и графики 18–20 века.
Государственная третьяковская галлерея:
Москва 1931. pp.46. [115.]

летопись изобразительного искусства.
Москва.

1934.
1935.
1936.
1937.
1938.
1939.
1940.
1941.
1942.
1943.
1944.
1945. pp.42.52. .56. [2307.]
1946. pp.52.48.62. . [3400.]
1947. pp.72.84. .66. [3882.]
1948. pp.72.102.80.86. [5210.]
1949. pp.94.104.112.104. [5984.]
1950. pp.100.104.100.120. [5987.]
1951. pp.112.124.104.126. [7347.]
1952. pp.96.112.112.140. [7418.]
1953.
1954. pp.72.109.156.156. [8604.]
1955. pp.188.129.153.132. [9485.]

1956. pp.208.160.128.155. [10,707.]
1957. pp.272.168.140.254. [14,224.]
1958. pp.216.192.184.263. [14,691.]
1959. pp.239.212.212.296. [17,140.]
1960. pp.256.236.288.251. [17,991.]
1961. pp.271.233.219.216. [15,581.]
1962. pp.277.176.227.276. [15,701.]
1963. pp.272.257. . .

in progress.

RUSSIA. A check list preliminary to a basic bibliography of materials in the russian language. Part III. Fine arts. Library of Congress: Reference department: Washington 1944. ff.38. [788.]*

AMREI ETTLINGER and JOAN M. GLADSTONE, Russian literature, theatre and art. A bibliography of works in english published 1900–1945. [1947]. pp.96.

YU. A. DMITRIEV, Путеводитель. Искусство. Главное архивное управление: Москва 1959. pp.446. [large number.]

ЛИТЕРАТУРА и искусство народов СССР и зарубежных стран. Библиографический бюллетень. Выходит 6 раз в год. Всесоюзная книжная палата и Всесоюзная государственная библиотека иностранной литературы: Москва.

1958. pp.246.231.195.203.200.263. [16,579.]

1959. pp.242.270.266.213.232. [14,549.]

1960. pp.235.246.286.280.256.240. [18,487.]

1961. pp.237.275.254.238.266.227. [18,129.]

1962.

1963. pp.292.240.265.226. . .

in progress.

Santo Domingo

LUIS FLORÉN LOZANO, Bibliografía de las bellas
artes en Santo Domingo. Materiales para el estudio
de la cultura dominicana (vol.viii): Bogotá 1956.
pp.3–53. [426.]

Scandinavia

NORDISK konstbibliografi. Tidskrift för konst-
vetenskap: Lund.

1920. Redigerad af Fritjof Hazelius. pp.36.
[565.]

1921. pp.37–62. [419.]

1922. pp.63–94. [529.]

1923. Redigerad af A[ron] J[ohan] T[eodor]
Borelius. pp.95–126. [538.]

no more published.

Slovakia

PAVOL STANO, Bibliografia slovenského ľudo-
vého výtvarného umenia so zreteľom no hmotnú

kultúru of vzniku záujmu o ľudové výtvarné umenie do konca roku 1957. Matica slovenská: Martine 1959. pp.329. [2032.]

Spain

MATILDE LÓPEZ SERRANO, Bibliografía de arte español y americano. Consejo superior de investigaciones cientificas: Instituto Diego Velasquez: Madrid 1942. pp.243. [3507.]

United States

FRANK H. CHASE, A bibliography of american art and artists before 1835. Boston 1918. pp.32. [600.]

on the cover the title reads Early american art.

BRIEF list of books on the history of art in the United States. Library of Congress: Washington 1919. ff.3. [21.]*

COLONIAL architecture and other early american arts. Carnegie library: Pittsburgh 1926. pp.28. [250.]

[ALLEN HENDERSHATT EATON], Handicrafts in the southern highlands. Russell Sage foundation: Library: Bulletin (no.145): New York 1937. pp.6. [150.]

SARO JOHN RICCARDI, Pennsylvania dutch folk art and architecture. A selective annotated bibliography. Public library: New York 1942. pp.15. [150.]

[INES VON DER MÜHLL], Die ausstellung Amerikanische kunstbücher in der Schweizerischen landesbibliothek in Bern. Swiss–american society for cultural relations: Publications series (vol.ii): Zürich 1944. pp.56. [371.]

HAROLD E[DWARD] DICKSON, A working bibliography of art in Pennsylvania. Pennsylvania historical and museum commission: Harrisbourg 1948. pp.iv.148. [2250.]*

RICHARD S. MAXWELL, Preliminary inventory of the records of the Commission of fine arts. National archives: Preliminary inventories (no. 79): Washington 1955. pp.v.38. [150.000.]*

AMERICAN art and art education. United States information agency: Information center service: Subject bibliography (no.21): [Washington] 1956. ff.[ii].47. [200.]*

ART, architecture, and design in the United States. United States information agency: Information center service: Subject bibliography (no.39): [Washington] 1958. pp.[iii].18. [66.]*

Art

Yugoslavia

ZORAN T. STOŠIĆ, Jugoslovenska bibliografija likovne umetnosti od 1945–1949 godine. Savez likovih umetnika Jugoslavije: Beograd 1951.pp.7.

7. Miscellaneous

ABRIDGMENTS of specifications relating to artists' instruments and materials, A.D. 1618–1866. Commissioners of patents for inventions: 1872. pp.xx.180. [250.]

ABRIDGMENTS of specifications. Class II. Artists' instruments and materials. Patent office.

1855–1866. pp.viii.20 [75.]
1867–1876. pp.viii.22. [75.]
1877–1883. pp.v.20. [75.]
1884–1888. pp.vii.34. [125.]
1889–1892. pp.vii.38. [125.]
1893–1896. pp.viii.40. [150.]
1897–1900. pp.viii.42. [150.]
1901–1904. pp.x.56. [200.]
1905–1908. pp.x.78. [300.]
1909–1915. pp.viii.65. [250.]
1916–1920. pp.viii.24. [100.]
1921–1925. pp.ix.56. [200.]
1926–1930. pp.ix.38. [125.]
no more published.

[LIDA A. THOMPSON], Children's reading-list on art and artists. Bulletin of bibliography pamphlets (no.8): Boston 1900. pp.14. [200.]

PATENTS for inventions. Fifty years subject index, 1861–1910. Class II. Artists' instruments and materials. Patent office: 1913. pp.9. [1000.]

A SHORT list of books on nature forms in art. Library of Congress: Washington 1935. ff.3. [18.]*

ART, archéologie, ethnographie. Bibliographie rétrospective des années 1940–1945. No.1. Office international des musées: Paris [1946]. pp.32. [600.]
a fragment only; contains very little archaeology and no tehnography; no more published.

JESSIE CROFT ELLIS, Nature and its applications. . . . References to nature forms and illustrations as used in every way. Useful reference series (no.74): Boston 1949, pp.xii.861. [200,000.]

WILBUR M. SMITH, A bibliography of the influence of the Bible on english literature (and in part on the fine arts). Fuller theological seminary: Fuller library bulletin (nos.9–10): Pasadena, Col. 1951. pp.15. [100.]
a supplement by the author appears in the Fuller library bulletin *(1951), xi.5.*

RUTHERFORD JOHN GETTENS and BERTHA M. USILTON, Abstracts of technical studies in art and archeology 1943–1952. Freer gallery of art: Occasional papers (vol.2, no.2): Washington 1955. pp.viii.408. [1399.]

WILLIAM B. O'NEAL, Jefferson's fine arts library for the university of Virginia. Charlottesville 1956. pp.53. [200.]

LOUIS FERRAND and EDMOND MAGNAC, Guide bibliographique de l'imagerie populaire. Auxerre 1956. pp.vii.40. [525.]
300 copies printed.

HERMANN GRAF, Bibliographie zum problem der proportionen. Literatur über proportionen, mass und zahl in architektur, bildender kunst und natur. Pfälzische arbeiten zum buch- und bibliothekswesen und zur bibliographien (no.3): Speyer.

 i. Von 1800 bis zur gegenwart. 1958. pp.96: [900.]

MARY L. SHAFFER, A bibliography of juvenile holdings in the Library of Congress in classification N–ND. Catholic university of America: Washington 1959. ff.[iv].97. [350.]*

GOTTFRIED ROST and HELMUT SCHULZE, Der sozialistische realismus in kunst und literatur.

Eine empfehlende bibliographie. Deutsche büche-
rei: Sonderbibliographien (no.21): Leipzig 1960.
pp.128. [1500.]

VINCENT LANIER, Doctoral research in art edu-
cation. [Los Angeles] 1962. pp.[ii].52.[xx]. [450.]★

Archaeology, antiquities. [*see also* **Anthropology** *and* **Folklore.**]

Archaeology

1. Bibliographies and periodicals

E. JEFFRIES DAVIS and E[VA] G[ERMAINE] R[IMINGTON] TAYLOR, Guide to periodicals and bibliographies dealing with geography, archaeology, and history. Historical association: Pamphlet (no.110): 1938. pp.23. [archaeology: 29.]

C[ARLEMILIA] FANFANI and F[RANCESCA] ROSELLI, Catalogo dei periodici della biblioteca dell' Istituto nazionale di archeologia e storia dell' arte. Roma 1947. pp.70. [1250.]

ALBERT VECQUERAY, Catalogue des périodiques de l'Institut archéologique liégeois, déposés à la bibliothèque de l'université de Liège. [Liège].*
 i. Répertoire alphabétique des titres. 1957. ff.[ii].47. [800.]

ROBERTO PEREZ DE AZEVEDO, Un dia ... y otro dia mas (esquema de recopilación periodistica). Cuaderna 1. Prehistoria, paleontología. La Habana 1959. pp.20. [200.]

HANS JÜRGEN ASCHENBORN, Anthropological and archaeological journals in south african libraries. State library: Bibliographies (no.2): Pretoria 1961. ff.[18]. [150.]*

Archaeology

WALTER WAGNER, Verzeichnis der zeitschriften in der bibliothek. Deutsches archäologisches institut: Römisch-germanische kommission: Bericht (no.43, beiheft): Berlin 1963. pp.[v].96. [1350.]

2. *General*

JOHANN ALBERT FABRICIUS, Bibliographia anti-qvaria, sive introdvctio in notitiam scriptorvm, qvi antiqvitates hebraicas, graecas, romanas et christianas scriptis illustravervnt. Hambvrgi &c. 1713. pp.[xvi].648.[iv].20.13. [4000.]

—— Editio secunda. 1716. pp.[xiv].604.[lxiv]. [5000.]

——— Joh. Mathæi Barthii . . . Mantissa in b. I. Alb. Fabricii Bibliographiam antiquariam. Ratisbonæ 1751. pp.103. [1500.]

—— Editio tertia, ex mscpto b. avctoris insigniter locvpletata et recentissimorvm scriptorvm recensione avcta, stvdio et opera Pavlli Schaffshavsen. 1760. pp.[xviii].1039.[cxvi]. [10,000.]

[NICHOLAS CARLISLE], A catalogue of the printed books in the library of the Society of antiquaries. 1816. pp.[iii].260. [3000.]

—— List of the printed books [&c.]. 1861. pp.[viii].166. [5000.]

— — — Supplement. [By C. Knight Watson].
1868. pp.iv.128. [3500.]

— — Printed boooks [&c.]. 1887. pp.[ii].800.
[15,000.]

— — — Supplement. 1899. pp.390. [7500.]

[SIR HENRY ELLIS], A catalogue of manuscripts
in the library of the Society of antiquaries. 1816.
pp.[iii].92. [1000.]

CATALOGO ragionato dei libri d'arte e d'anti-
chità posseduti dal conte [Leopoldo] Cicognara.
Pisa 1821. pp.xiv.415+[iii].333.lxxviii. [anti-
quities: 2326.]
this collection is now in the Vatican library.

A CATALOGUE of the manuscripts, books . . .
belonging to the Society of antiquaries, of
Newcastle upon Tyne. Newcastle 1839. pp.[iii].
95. [1000.]

— A catalogue of the library belonging [&c.].
1863. pp.[iii].108. [1500.]

— — 1896. pp.176. [3000.]

KATALOG der bibliothek der Antiquarischen ge-
sellschaft in Zürich. Zürich 1855. pp.x.29. [1000.]

ALEXIS DUREAU, Notes bibliographiques pour
servir à l'étude de l'histoire et de l'archéologie.

1^{re} année, 1863. 1866. pp.276. [1500.]
no more published.

CATALOGUE of books in the library of the British archaeological society of Rome. [Rome] 1871. pp.46. [500.]

[FREDERIK MULLER], Catalogus der bibliotheek van het Koninklijk oudheidkundig genootschap. Amsterdam 1878. pp.vii.50. [566.]

CARL BERNHARD STARK, Handbuch der archäologie der kunst. . . . Erste abtheilung. Systematik und geschichte der archäologie der kunst. Leipzig [1878-]1880. pp.viii.400. [2500.]

[COUNT] ROBERT [CHARLES] DE LASTEYRIE [DU SAILLANT], Bibliographie générale des travaux historiques et archéologiques publiés par les sociétés savantes de la France. 1888–1904. pp.[iii].xi.707+ [iii].ii.740+[iii].xxxi.784+xxiv.725. [83,818.]

—— Supplément, 1886–1900. [1905-]1911–1918. pp.[v].831+xii.846. [48,417.]

[*continued as:*]

Bibliographie annuelle des travaux historiques et archéologiques publiés par les sociétés savantes de la France.

1901–1902. 1904. pp.viii.287. [3411.]
1902–1903. 1905. pp.[v].261. [5227.]

1903–1904. 1906. pp.[v].289. [5353.]

1904–1905. 1907. pp.[iii].217. [4695.]

1905–1906. 1908. pp.[iii].202. [4304.]

1906–1907. 1909. pp.[iii].265. [5038.]

1907–1908. 1910. pp.[iii].207. [4277.]

 *the last number in this volume is misprinted
 33295 for 32295.*

1908–1909. 1911. pp.[iii].207. [4424.]

1909–1910. 1914. pp.[iii].320. [5893.]

1910–1940. 1944–1961. pp.vii.506+vii.577+
 viii.832+viii.1081+viii.583. [124,000.]

[*continued as:*]
Bibliographie générale [&c.]. Par René Gan-
dilhon . . . sous la direction de Charles Samaran.
Période 1910–1940.

 i. Ain–Creuse. 1944. pp.vii.506. [15,942.]

 ii. Dordogne–Lozère. 1950. pp.vii.577.
 [18,231.]

 iii. Maine-et-Loire. [1951–]1953. pp.iii–
 viii.832. [25,965.]

 iv. Seine. [1956–]1958. pp.iii–viii.1061.
 [44,744.]

 v. Seine-et-Marne–Yonne, France d'outre-mer
 et étranger. 1961. pp.iii–viii.583. [19,138.]
 *the original title was retained on the covers
 of the first three volumes of the new series.*

Archaeology

ARCHÄOLOGISCHER anzeiger. Beiblatt zum Jahr-
buch des Archäologischen instituts. Berlin.

1889. pp.[ii].220. [2500.]
1890. pp.198. [2500.]
1891. pp.221. [2500.]
1892. pp.204. [2500.]
1893. pp.228. [2500.]
1894. pp.222. [2500.]
1895. pp.270. [3000.]
1896. pp.251. [3000.]
1897. pp.248. [3000.]
1898. pp.298. [3500.]
1899. pp.262. [3000.]
1900. pp.281. [3500.]
1901. pp.272. [3500.]
1902. pp.208. [2500.]
1903. pp.244. [3000.]
1904. pp.255. [3000.]
1905. pp.216. [2500.]
1906. coll.394. [2500.]
1907. coll.562. [3500.]
1908. coll.616. [3500.]
1909. coll.670. [4000.]
1910. coll.650. [4000.]
1911. coll.560. [3500.]
1912. coll.746. [4500.]

after this issue the more strictly bibliographical

Archaeology

sections were separated from the Anzeiger *and continued as:*

Bibliographie zum Jahrbuch des Archäologischen instituts.

 1913. pp.[ii].coll.156. [2500.]
 1914. pp.[ii].coll.102. [1500.]
 1915. pp.[ii].coll.80. [1250.]
 1916–1917. pp.[ii].coll.86. [1250.]
 1918–1919. pp.[ii].coll.80. [1250.]
 1920–1922. coll.226. [4000.]
 1923–1924. coll.162. [2500.]
 1925. coll.106. [2000.]
 1926. coll.134. [2500.]
 1927. coll.132. [2500.]
 1928. coll.140. [2500.]
 1929. coll.140. [2500.]
 1930. coll.158. [2500.]
 1931. Bearbeitet von Paul Geissler. coll.340.
 [3866.]

[continued as:]

Archäologische bibliographie. Beilage zum Jahrbuch des Deutschen archäologischen instituts.

 1932. Bearbeitet von P. Geissler. coll.282.
 [3367.]
 1933. coll.288. [3500.]
 1934. coll.278. [3312.]
 1935. coll.320. [3829.]

1936. coll.296. [3493.]

1937. coll.300. [3700.]

1938. coll.326. [3816.]

1939. coll.294. [3436.]

1940. coll.266. [3018.]

1941. coll.270. [3142.]

1942. coll.220. [2448.]

1943. 1947. coll.204. [2345.]

1944–1948. Bearbeitet von Gerhard Reincke.
 1950. coll.xlii.350. [4520.]

1949. 1952. coll.xxviii.340. [4048.]

1950–1951. 1952. coll.xxviii.364. [4567.]

1952–1953. 1955. coll.xxvii.418. [5543.]

1954. 1956. coll.xxviii.338. [4294.]

1955. 1957. coll.xxv.276. [3396.]

1956. 1958. coll.xxvi.322. [4005.]

1957. 1959. coll.xxvi.326. [4056.]

1958. 1960. coll.xvi.346. [4242.]

1959. 1961. coll.xvi.352. [4299.]

1960. 1962. coll.xvi.388. [4582.]

1961.

in progress.

[E. C. HULME], Catalogue of the library of the Royal archaeological institute of Great Britain and Ireland. 1890. pp.[iv].120. [2000.]

ΚΑΤΑΛΟΓΟΣ των βιβλιων της Ἐθνικης βι-

Archaeology

βλιοθηκης της ῾Ελλαδος. Τμημα ε΄. ᾿Αρχαιο-
λογια. ᾿Αθηναις 1891. pp.[vii].119. [2500.]

INDEX to archæological papers. Congress of
archæological societies and Society of antiquaries.

1891. 1892. pp.[ii].40. [600.]

1892. 1893. pp.40. [600.]

1893. 1894. pp.36. [500.]

1894. 1895. pp.52. [800.]

1895. 1896. pp.46. [700.]

1896. 1897. pp.53. [800.]

1897. 1898. pp.52. [800.]

1898. Compiled by [sir] G[eorge] Laurence
Gomme. 1899. pp.41. [600.]

1899. 1900. pp.55. [800.]

1900. 1901. pp.49. [700.]

1901. 1902. pp.51. [800.]

1902. 1903. pp.46. [700.]

1903. 1904. pp.59. [900.]

1904. Compiled by Bernard Gomme. 1905.
pp.82. [1200.]

1905. 1906. pp.63. [900.]

1906. 1907. pp.66. [900.]

1907. 1908. pp.70. [1000.]

1908. Compiled by Allan Gomme. 1912.
pp.86. [1100.]

'1909. Compiled under the direction of William Martin. 1914. pp.74. [1000.]

1910. 1914. pp.67. [800.]
no more published; a work intended to precede the present series is entered below, 1907.

J[OHN] POTTER BRISCOE and S. J. KIRK, Archaeology and antiquities. Public reference library: Class list (no.19): Nottingham 1894. pp.23. [450.]

CATALOGUE of the books in the Wilson archæological library in Marischall college. University of Aberdeen: Aberdeen 1894. pp.18. [350.]

КАТАЛОГЪ библіотеки музея древностей. С.-Петербургъ 1896. pp.iv.212. [2500.]

WILLIAM SWAN SONNENSCHEIN, A bibliography of archæology and antiquities. Being the sections relating to those subjects in The best books and The reader's guide. 1897. pp.[ii].463-486. 353-374. [1500.]

ERAZM MAJEWSKI, Przegląd literatury przed i protohistorycznej z ostatniego dziesięciolecia. Warszawa 1898. pp.28. [60.]

AUGUST MAU, Katalog der bibliothek des Kaiserlich deutschen archaeologischen institutes in Rom. Rom 1900-1902. pp.x.431+xv.616. [15,000.]

—— Neu bearbeitet von Eugen von Mercklin [ii: und Friedrich Matz]. [1913–] 1914–1932. pp.xviii.758 + vii.759–1449 + xxxv.949 + ix. 951–1706. [60,000.]

——— 1. supplement . . . 1911–1925. Berlin 1930. pp.xxix.516. [10,000.]

SIR GEORGE LAURENCE GOMME, Index of archæological papers, 1665–1890. Congress of archæological societies and Society of antiquaries: 1907. pp.xi.910. [17,500.]

intended to precede the work entered above, 1891 &c.

ÉTIENNE DEVILLE, Index du Mercure de France, 1677–1832, donnant l'indication . . . de toutes les notices, mentions, annonces, planches, etc., concernant les beaux-arts et l'archéologie. Publications pour faciliter les études d'art en France: 1910. pp.iii–xl.269. [12,500.]

350 copies printed.

RÉPERTOIRE d'art et d'archéologie. Dépouillement des périodiques. 1910 &c.

in progress; details of this work are entered under Art, below.

W. T. LANCASTER, Catalogue of manuscripts in the library of the Yorkshire archaeological society. Leeds 1912. pp.[iii].iii.52. [5000.]

THE ATHENÆUM subject index to periodicals. . .
Fine arts and archæology.

> [1915. 1915.] pp.[ii].15. [400.]
> — Second edition. 1916. pp.[ii].33. [1000.]
> 1916. 1918. pp.44. [1500.]
> *[continued as:]*

The subject index to periodicals . . . G. Fine arts
and archæology. Library association.

> 1917–1919. 1921. pp.[ii].coll.212. [4000.]
> 1920. 1923. pp.[ii].coll.106. [2000.]
> 1921. 1924. pp.[ii].coll.110. [2000.]
> 1922. 1926. pp.[ii].coll.124. [2500.]

subsequent issues were not published in sections.

BRIEF list of books on archaeology. Library of
Congress: Washington 1920. ff.8. [84.] &c.

VORGESCHICHTLICHES jahrbuch. Gesellschaft für
vorgeschichtliche forschung: Berlin &c.

> i. 1924. Herausgegeben von Max Ebert.
> 1926. pp.vi.157. [1000.]
> ii. 1925. 1926. pp.iv.344. [3000.]
> iii. 1926. 1928. pp.iv.406. [3000.]
> iv. 1927. 1930. pp.iv.424. [3000.]

no more published.

CATALOGUE of books in the library at the
Athenæum, Bury St. Edmunds. Suffolk institute

of archæology and natural history: Ipswich [printed] 1933. pp.30.

BOOKS on art, architecture and archæology published during 1936. pp.16 [250.]
limited to works published in Great Britain.

[REGINALD ARTHUR RYE], Catalogue of books on archæology and art and cognate works belonging to the Preedy memorial library and other collections in the university library. University of London: [1935–]1937. pp.[v].xviii.438. [10,000.]
[—] — Supplement. 1937. pp.28. [750.]

CATALOGUE of library. Archæological survey, Ceylon: Colombo 1938. pp.[ii].75. [2000.]

[CHARLES DACKWEILER], Catalogue de la bibliothèque. Institut archéologique de Luxembourg: Annales (vol.lxxi): Arlon 1940. pp.viii.240. [3000.]

THE READERS' guide to prehistory and archaeology. Library association: County libraries section (no.32). 1940. pp.24. [500.]

MAJA LUNDQUIST, Biblioteca monteliana. Catalogue of Oscar Montelius' collection of books included in the library of the Kungl. vitterhets historie och antikvitets akademien, Stockholm. Kungl. vitterhets historie och antikvitets akade-

mien: Handlingar (vol.lvii): Stockholm 1943.
pp.lii.248. [3000.]
not entirely limited to archaeology.

OLD WORLD bibliography. Recent publications
mainly in old world palæolithic archæology and
palæo-anthropology. Peabody museum: Amer-
ican school of prehistoric research: Cambridge,
Mass.*

i. 1948. By Hallam L[eonard] Movius.
ii. 1949.
iii. 1950. pp.51. [600.]
iv. 1951. pp.65. [750.]
v. 1952. pp.74. [850.]
vi. 1953. pp.79. [950.]
vii. 1954. pp.86. [1000.]
viii. 1955. pp.88. [1000.]
no more published.

KARL SCHEFOLD, Orient, Hellas und Rom in der
archäologischen forschung seit 1939. Wissen-
schaftliche forschungsberichte: Geisteswissen-
schaftliche reihe (vol.15): Bern 1949. pp.248.
[1000.]

J[OZEFF] M[ARIE] A[NTOON] JANSSEN, K. SCHE-
FOLD and V. D. BLAVATSKIJ, Literaturberichte für
die jahre 1939–1947. Deutsches archäologisches

institut: Jahrbuch (ergänzungsheft 16): Berlin 1950. pp.xi. [1324.]

SWEDISH archaeological bibliography. Svenska arkeologiska samfund: Uppsala [ii: Stockholm].
 1939–1948. Edited by Sverker Janson and Olof Vessberg. 1951. pp.360. [1250.]
 1949–1953. Edited by Christian Callmer and Wilhelm Holmqvist. 1956. pp.viii.294. [1094.]

ANNUARIO bibliografico di archeologia. (Opere e periodici entrati in biblioteca....). Istituto nazionale d'archeologia e storia dell'arte: Modena.
 i. 1952. A cura di Cesare d'Onofrio. 1954. pp.3–194. [910.]
 ii. 1953. 1955. pp.3–327. [2056.]
 iii. 1954. 1956. pp.3–312. [2149.]
 iv. 1955. 1957. pp.3–307. [2255.]
 v. 1956. 1958. pp.3–276. [2102.]
 vi. 1957. 1960. pp.3–312. [2514.]
 vii. 1958. 1962. pp.3–320. [2567.]
 in progress.

НОВАЯ советская литература по истории, археологии и этнографии. Академия наук СССР. Фундаментальная библиотека общественных наук: Москва 1960 &c.
 in progress.

новая иностранная литература по истории, археологии и этнографии. Академия наук СССР: Фундаментальная библиотека общественных наук: Москва 1960 &c.

in progress.

JANE CLAPP, Museum publications. Part 1. Anthropology, archaeology and art. New York 1962. pp.434. [4416.]*

AUTHOR and subject catalogues of the library of the Peabody museum of archaeology and ethnology, Harvard university. Boston 1963.

details of this work are entered under Anthropology: General, above.

3. *Countries &c.*

Africa

A[STLEY] J[OHN] H[ILARY] GOODWIN, The loom of prehistory.... A commentary and select bibliography of the prehistory of southern Africa. South african archaeological society: Handbook series (no.2): Claremont 1946. pp.151. [250.]

[GILBERT CHARLES PICARD], Archéologie. Afrique du nord, Italie. Association pour la diffusion de la pensée française: Bibliographie française établie à

l'intention des lecteurs étrangers: 1959. pp.54. [460.]

limited to works published since 1945.

NORTHWEST AFRICA. Council for old world archaeology: COWA surveys bibliographies: Cambridge, Mass. 1961 &c.

in progress.

NORTHEAST AFRICA. Council for old world archaeology: COWA surveys bibliographies: Cambridge, Mass. 1961 &c.

in progress.

WEST AFRICA. Council for old world archaeology: COWA surveys bibliographies: Cambridge, Mass. 1961 &c.

in progress.

EQUATORIAL AFRICA. Council for old world archaeology: COWA surveys bibliographies: Cambridge, Mass. 1961 &c.

in progress.

EAST AFRICA. Council for old world archaeology: COWA surveys bibliographies: Cambridge, Mass. 1961 &c.

in progress.

SOUTH AFRICA. Council for old world archaeo-

logy: COWA surveys bibliographies: Cambridge, Mass. 1961 &c.

Algeria

LIONEL BALOUT, La préhistoire. Gouvernement général de l'Algérie: Sous-direction des beaux-arts: Vingt cinq ans d'histoire algérienne, recherches et publications, 1931–1956. (vol.i): Alger 1958. pp.35. [200.]

in progress.

America

AD[OLPH] F[RANCIS ALPHONSE] BANDELIER, Notes on the bibliography of Yucatan and central America; comprising Yucatan, Chiapas, Guatemala (the ruins of Palenque, Ocosingo, and Copan), and Oaxaca (ruins of Mitla). Worcester [Mass.] 1881. pp.39. [400.]

LÉON LEJEAL, Les antiquités mexicaines (Mexique, Yucatan, Amérique-centrale). Société des études historiques: Bibliothèque de bibliographies critiques [no.19]: 1902. pp.79. [388.]

LOUISE GUERBER, Cliff dwellers and cliff dwellings of north America. A selected bibliography. Public library: Denver 1925. pp.21. [350.]

JOHN OTIS BREW, A selected bibliography of american indian archaeology east of the Rocky mountains. Excavators' club: Papers (vol.ii, no.1): Cambridge, Mass. 1943. pp.v.90. [1500.]*

BIBLIOGRAPHICAL list of articles, books, and references to Virginia Indians, with particular emphasis on archaeology. Archaeological society of Virginia: [Richmond] 1942–1956.*
details of this work are entered under American Indians, above.

RICHARD G[UY] MORGAN and JAMES H[OWARD] RODABAUGH, Bibliography of Ohio archaeology. Ohio state archaeological and historical society: Columbus 1947. pp.v.189. [1351.]

A COLLECTION of books pertaining to the archæology, ethnology & anthropology of Mexico, Guatemala and central America ... presented by Matilda Geddings Cray to the Museo nacional de antropología de Guatemala. San Francisco 1948. pp.[iii].107. [500.]
200 copies printed.

ABSTRACTS of new world archaeology. Society for american archaeology: [Washington].
 i. 1959. Edited by Richard B. Woodbury,

Archaeology

pp.[v].127. [676.]
ii. 1960. pp.viii.184. [1124.]

IGNACIO BERNAL [GARCÍA PIMENTEL], Bibliografía de arqueología y etnografía: Mesoamérica y norte de México, 1514–1960. Instituto nacional de antropología e historia: Memorias (no.7): México 1962. pp.iii–xvi.635. [13,990.]

Asia

M. N. BASU, An alphabetical index to the classified catalogue of the library of the Director general of archaeology. Calcutta 1917. pp.[iii].162 +[iii].302. [2500.]
the library covers asiatic archaeology in general.

RICHARD K[ING] BEARDSLEY, JOHN B. CORNELL and EDWARD NORBECK, Bibliographic materials in the japanese language on far eastern archaeology and ethnology. [University of Michigan:] Center of japanese studies: Bibliographical series (no.3): Ann Arbon 1950. pp.ix.74. [1063.]

BIBLIOGRAPHIE analytique de l'assyriologie et de l'archéologie du proche-orient. Section PH. La philologie. Leyde.
 i. 1954–1956. Par L. Vaden Berghe et L. de Meyer. pp.xii.108. [950.]

FAR EAST. Council for old world archaeology: COWA surveys bibliographies: Cambridge, Mass. 1961 &c.

in progress.

NORTHERN ASIA. Council for old world archaeology: COWA surveys bibliographies: Cambridge, Mass. 1961 &c.

in progress.

WESTERN ASIA. Council for old world archaeology: COWA surveys bibliographies: Cambridge, Mass. 1961 &c.

in progress.

SOUTHERN ASIA. Council for old world archaeology: COWA surveys bibliographies: Cambridge, Mass. 1961 &c.

in progress.

SOUTHEAST ASIA. Council for old world archaeology: COWA surveys bibliographies: Cambridge, Mass. 1961 &c.

in progress.

Australia

AUSTRALIA. Council for old world archaeology: COWA surveys bibliographies: Cambridge, Mass. 1961 &c.

in progress.

Archaeology
Austria

RICHARD PITTIONI, Bibliographie zur urge-
schichte Österreichs (einschliesslich Deutsch-
südtirol). Bibliographie zur geschichte, landes-
und volkskunde Österreichs (ergänzungsband i):
Linz 1931. pp.viii.245. [2972.]

—— [supplement]. Bibliographie zur urge-
schichte der Ostmark, 1930–1938. Wien 1940.
pp.[vi].121. [710.]

Baltic states

ANTON BUCHHOLTZ, Bibliographie der archäo-
logie Liv-, Est-, und Kurlands. Riga 1896. pp.iv.61.
[771.]

Belgium

ANNE MARIE KNAPEN-LESCRENIER, Répertoire
bibliographique des trouvailles archéologiques en
Brabant. Les âges de la pierre. Centre national de
recherches archéologiques en Belgique: Réper-
toires archéologiques (no.1): Bruxelles 1960. pp.
viii.109. [1000.]

JACQUES STIENNON, Archéologie, épigraphie,
héraldique liégeoises. Le fonds Paul Lohest. Biblio-
theca universitatis leodiensis: Publications (no.12):
Liège 1962. pp.67. [large number.]

Archaeology

Biblical

[WILLIAM RICKETTS COOPER], Catalogue of the library of the Society of biblical archaeology. 1876. pp.xv.109. [1250.]

Bulgaria

SONYA GEORGIEVA and VELIZAR VELKOV, Библиография на българската археология (1879–1955). Българска академия на науките: Археологически институт: Централна библиотека: София 1957. pp.384. [6305.]

BULLETIN d'analyses de la littérature scientifique bulgare. Histoire et archéologie. Académie des sciences de Bulgarie: Centre d'information et de documentation scientifiques et techniques: Sofia.*
 i. 1958. pp.[iv].103. [159.]
 ii. 1959. pp.[ii].80. [138.]
 iii. 1960. pp.[iv].92. [156.]
 iv. 1961. pp.[ii].48. [228.]
in progress; also issued in a german edition.

Classical, see Classical studies

Dacia

KÁROLY TORMA, Repertórium Dacia régiség- és

felirattani irodalmához. Magyar tudományos
akadémia archæologiai bizottsága: Budapest 1880.
pp.xxxii.191. [1500.]

Danubian basin

JÁNOS BANNER and IMRE JAKABFFY, A közép-
dunamedence régészeti bibliográfiája a legrégibb
időktől a XI. századig. Budapest 1954. pp.582.
[17,605.]

—— 1954–1959. 1961. pp.252. [3912.]

Ecuador

CARLOS MANUEL LARREA, Bibliografia cientifica
del Ecuador. [Parte cuarta. Antropologia, etno-
grafia, arqueologia]. Quito 1952. pp.[v].325–561.
[1516.]

Egypt

BERTHA PORTER and ROSALIND L[OUISA] B[EAU-
FORT] MOSS, Topographical bibliographical biblio-
graphy of ancient egyptian hieroglyphic texts,
reliefs, and paintings. Oxford.

 i. The Theban necropolis. 1927. pp.xix.212.
 [6000.]
 — Second edition. 1960– . pp.503+ .
 ii. Theban temples. 1929. pp.xviii.204. [6000.]
 iii. Memphis (Abû Rawâsh to Dahshûr).
 1931. pp.xxii.255. [7000.]

iv. Lower and middle Egypt (delta and Cairo to Asyût). 1934. pp.xxviii.295. [8000.]

v. Upper Egypt: sites (Deir Rîfa to Aswân, excluding Thebes and the temples of Abydos, Dendera, Esna, Edfu, Kôm Ombo and Philae). 1937. pp.xxiv.292. [8000.]

vi. Upper Egypt: chief temples (excluding Thebes), Abydos, Dendera, Esna, Edfu, Kôm Ombo, and Philae. 1939. pp.xx.264. [7000.]

vii. Nubia, the deserts, and outside Egypt. 1951. pp.xxxvi.454. [12,500.]

NADIA SAUNERON, Temples ptolémaïques et romains d'Égypte. Études et publications parues entre 1939 et 1954. Répertoire bibliographique. Institut français d'archéologie orientale: Bibliothèque d'étude (vol.xiv): Le Caire 1956. pp.xi.197. [10,000.]

Europe

CENTRAL EUROPE. Council for old world archaeology: COWA surveys bibliographies: Cambridge, Mass. 1961 &c.

in progress.

WESTERN EUROPE. Council for old world ar-

chaeology: COWA surveys bibliographies: Cambridge, Mass. 1961 &c.

in progress.

BALKANS. Council for old world archaeology: COWA surveys bibliographies: Cambridge, Mass. 1961 &c.

in progress.

France

É[MILE] TAILLEBOIS and H[ENRY] POYDENOT, Bibliographie pour le Congrès archéologique de Dax et Bayonne. 1888. pp.20. [400.]

a bibliography, mainly archaeological, of the Landes and Bayonne.

A[LFRED] PERRAULT-DABOT, Catalogue de la bibliothèque de la Commission des monuments historiques. Ministère de l'instruction publique: 1895. pp.[iii].331. [2869.]
—— Supplément. 1901.

PHILIPPE DES FORTS, La collection Guilhermy à la Bibliothèque nationale. Caen [printed] 1905. pp.43. [1000.]

C. IMBERT, Bibliographie des travaux archéologiques dans la Charente. Caen [printed] 1915. pp.23. [60.]

RAOUL MONTANDON, Bibliographie générale

des travaux palethnologiques et archéologiques
(époques préhistorique, protohistorique et gallo-
romaine). France. Genève &c.

i. Bourgogne, Dauphiné, Franche-Comté,
Nivernais, Provence, Corse, Savoie. 1917.
pp.iii–xxxiii.600. [8710.]

ii. Alsace, Artois, Champagne, Flandre, Île-
de-France, Lorraine, Normandie, Picardie.
1920. pp.iii–xxviii.507. [8682.]

— Premier supplément. 1929. pp.xvi.86.
[697.]

iii. Anjou, Berry, Bretagne, Maine, Orléa-
nais, Poitou, Touraine. 1926. pp.xx.349.
[4888.]

— Premier supplément. 1928. pp.xv.69.
[468.]

iv. Angoumois, Aunis et Saintonge,
Auvergne, Bourbonnais, Limousin, Lyon-
nais, Marche. 1931. pp.xv.263. [3217.]

v. Béarn, comté de Foix, Guyenne et
Gascogne, Languedoc, Roussillon. 1938.
pp.xxxix.437. [5545.]

[ALEXANDRE] PARAT, Bibliographie des publica-
tions préhistoriques, archéologiques, historiques,
1893–1919. Notice archéologique sur la com-
mune de Guillon. Auxerre [printed] 1920. pp.6.
[150.]

Archaeology

MAX BRUCHET, Les monuments historiques du Nord. Notice et bibliographie. Commission historique du Nord: Lille 1922. pp.72. [1500.]

MAURICE TOUSSAINT, Répertoire archéologique du département des Vosges (période gallo-romaine). Epinal 1948. pp.[v].160. [700.]

HENRI POLGE, Topobibliographie monumentale du Gers. Auch [printed] 1952. pp.36. [600.]

[M. L. CORNILLOT and FRANÇOISE BLIND], Quinze ans d'archéologie historique en Franche-Comté, 1941–1955. Musée des Beaux-Arts: Besançon [c.1957]. pp.24. [40.]
an exhibition catalogue.

RENÉ PRÉVOST, Répertoire bibliographique des recherches préhistoriques dans le département du Pas-de-Calais. Commission des monuments historiques du Pas-de-Calais: Mémoires (vol.ix, part 1): Arras 1958. pp.136. [1100.]

BIBLIOGRAPHIE. Touring-club de France: Groupe d'archéologie antique: Notices techniques (no.1): [1961]. ff.11. [200.]*

Germany

HEINRICH ECK, Verzeichnis der mineralogischen, geognostischen, urgeschichtlichen und balneo-

graphischen literatur von Baden, Württemberg, Hohenzollern und einigen angrenzenden gegenden. 1890 &c.

details of this work are entered under Geology: Germany, below.

GEORG DUTSCHMANN, Literatur zur vor- und frühgeschichte Sachsens. Mannus-bibliothek (no.27): Leipzig 1921. pp.[v].32. [650.]

WILHELM DEECKE, Schrifttum zur ur- und frühgeschichte Badens, 1908–1953. Ausschuss für ur- und frühgeschichte Badens: Badische fundberichte (vol.iii, beiheft): [Freiburg i. Br.] 1935. pp.32. [750.]

BIBLIOGRAPHIE zur vor- und frühgeschichte Mitteldeutschlands. Herausgegeben von Martin Jahn. Sächsische akademie der wissenschaften zu Leipzig: Philologisch–historische klasse: Abhandlungen (vol.xlvii &c.).

 i. Sachsen-Anhalt und Thüringen. . . . Bearbeitet von Walther Schulz. . . . (vol.xlvii, no.1; l, no. 1): 1955–1962. pp.162+xxi. 652+xii. 653–942. [12,625.]

 ii. Land Sachsen. Bearbeitet von Georg Bierbaum. . . . (vol.xlviii, no.2): 1957. pp.190. [1726.]

Archaeology

Gold Coast

WILLIAM T[HOMAS] JAMES, A bibliography of Gold Coast geology, mining and archæology to March 1937. Gold Coast geological survey: Bulletin (no.9): Colchester [printed] 1937. pp.57. [530.]

Great Britain

WILLIAM HUDDESFORD, Catalogus librorum manuscriptorum viri clarissimi Antonii a Wood. Being a minute catalogue of each particular contained in the manuscript collections of Antony à Wood deposited in the Ashmolean museum. Oxford 1761. pp.[iv].84. [5000.]

—— Typis Medio-Montanis . . . re-impressus. 1824. pp.[iv].13–52. [5000.]

WILLIAM HENRY BLACK, A descriptive, analytical, and critical catalogue of the manuscripts bequeathed unto the university of Oxford by Elias Ashmole . . . also of some additional mss. contributed by Kingsley, Lhuyd, Borlase, and others. Oxford 1845. pp.[ii].coll.1522. [20,000.]

—— Index. [By William Dunn Macray]. 1866. pp.[iii].188.

[THOMAS HEARNE], Bibliotheca hearniana. Excerpts from the catalogue of the library of Thomas Hearne. . . . Printed from his own

manuscript. [Edited by Beriah Botfield]. 1848. pp.[iii].48. [1000.]

JOHN GOUGH NICHOLS, A bibliographical review of works on the sepulchral antiquities of England. 1867. pp.[ii].46. [100.]
privately printed.

W. HOWARD BELL and E[DWARD] H[UNGERFORD] GODDARD, Catalogue of the printed books, pamphlets, mss., and maps, in the library of the Wiltshire archæological and natural history society's museum. Devizes 1894. pp.[ii].100. [1500.]
— — Additions. 1895. pp.12. [150.]
— — Additions. 1897. pp.32. [400.]
— — Additions. 1899. pp.32. [400.]

W. H. DALTON, Catalogue of books, pamphlets, periodicals, mss., and scrap collections, in the library of the Essex archæological society. Colchester [printed] 1895. pp.51. [500.]

LIST of books in the library of the Glastonbury antiquarian society. Glastonbury [printed] 1910. pp.48. [600.]

ARTHUR H[ENRY] LYELL, A bibliographical list descriptive of romano-british architectural remains in Great Britain. Cambridge 1912. pp.xii. 156. [6000.]

G. E. KIRK, Catalogue of the printed books and pamphlets in the library of the Yorkshire archæological society... Leeds. Wakefield [printed] 1935–1936. pp.viii.296+268. [7500.]

LIST of printed books and pamphlets added to the library. Yorkshire archæological society: [Huddersfield].
> 1947. pp.8. [150.]
> 1948. pp.15. [250.]

ARCHAEOLOGICAL bulletin for the British isles. Council for british archaeology.
> 1940–1946. 1949. pp.vi.96. [868.]
> 1947. 1950. pp.viii.95. [507.]
> 1948–1949. 1952. pp.x.102. [978.]
>> [*continued as:*]

Archaeological bibliography for Great Britain and Ireland.
> 1950–1951. 1954. pp.xii.107. [1159.]
> 1952–1953. 1955. pp.xiii.133. [1424.]
> 1954. 1956. pp.xiii.115. [1008.]
> 1955. 1957. pp.xiii.129. [960.]
> 1956. 1958. pp.xiv.130. [874.]
> 1957. 1958. pp.xiv.130. [894.]
> 1958. 1960. pp.xiv.174. [1009.]
> 1959. 1960. pp.xiii.115. [837.]
> 1960. 1961. pp.xiii.127. [1029.]

Archaeology

1961. 1964. pp.viii.82. [747.]
in progress.

BRITISH archaeology. A book list. Council for british archaeology: 1960. pp.44. [750.]

BRITISH ISLES. Council for old world archaeology: COWA surveys bibliographies: Cambridge, Mass. 1961 &c.
in progress.

Hungary

JÁNOS BANNER, Bibliographia archaeologica hungarica. Dolgozatok a M. Kir. Ferencz József-tudományegyetem régiségtudományi intézetéből (vol.xiv &c.): Szeged 1938 &c.

— — [another edition]. 1944. pp.xv.558.

JÁNOS BANNER and IMRE JAKABFFY, A közep-Dunamedence régészeti bibliográfiája a legrégibb időktől a XI. századig. Akadémiai Kiedó: Budapest 1954. pp.581.

India

GEORGE BUIST, Index to books and papers on the physical geography, antiquities, and statistics of India. Bombay 1852. pp.5–103. [4000.]

A LIST of archæological reports, published under the authority of the Secretary of state, government of India, local governments, etc., which are not

included in the imperial series of such reports. Calcutta 1900. pp.13. [175.]

ANNUAL bibliography of indian archæology. Kern institute: Leyden.

[i]. 1926. pp.x.107. [540.]
[ii].1927. pp.x.143. [721.]
[iii]. 1928. pp.xi.141. [721.]
[iv]. 1929. pp.xi.141. [731.]
[v]. 1930. pp.xi.149. [929.]
[vi]. 1931. pp.xi.211. [982.]
vii. 1932. pp.xi.179. [752.]
viii. 1933. pp.xiii.133. [706.]
ix. 1934. pp.xi.167. [847.]
x. 1935. pp.xii.163. [832.]
xi. 1936. pp.vi.125. [807.]
xii. 1937. pp.x.136. [697.]
xiii. 1938. pp.xi.109. [787.]
xiv. 1939. pp.xi.71. [428.]
xv. 1940–1947. 1950. pp.lxxii.221. [2580.]
xvi. 1948–1953. 1958. pp.cviii.369. [4192.]
xvii. 1954–1957. 1962. pp.xvi.245. [2368.]
in progress?

Indonesia

INDONESIA. Council for old world archaeology:

Archaeology

COWA surveys bibliographies: Cambridge, Mass. 1961 &c.

in progress.

Ireland

[EVELYN PHILIP SHIRLEY], Catalogue of the library at Lough Fea, in illustration of the history and antiquities of Ireland. 1872. pp.vii.386. [3000.]

CHARLES MCNEILL, A short bibliography of irish archaeology. Bibliographical society of Ireland: Wexford [printed] 1927. pp.[16]. [250.]

Islam

ANNUAL bibliography of islamic art and archæology, India excepted. Jerusalem.
 i. 1935. Edited by L. A. Mayer. 1937. pp.[ix].
 64. [600.]
 ii. 1936. 1938.
 iii. 1937. 1939. pp.[ix].96. [900.]

K[EPPEL] A[RCHIBALD] C[AMERON] CRESWELL, A bibliography of the muslim architecture of Egypt. Art islamique (vol.iii): Le Caire 1955. pp.64. [750.]

ISLAMIC art and archaeology. Cambridge.*
 1954. Compiled by J[ames] D[ouglas] Pearson and D. S. Rice. 1956. pp. . [355.]

Archaeology

1955–1960. pp.[ii].iii.65. [478.]
in progress.

Italy

[GILBERT CHARLES PICARD], Archéologie. . . .
Afrique du nord, Italie. Association pour la diffu-
sion de la pensée française: Bibliographie française
établie à l'intention des lecteurs étrangers: 1959.
pp.54. [460.]
limited to works published since 1945.

Kirghiztan

Z. L. AMITIN-SHAPIRO, Аннотированный
указатель литературы по истории, архео-
логии и этнографии Киргизии, 1750–1917.
Академия наук Киргизской ССР: Институт
истории: Фрунзе 1958. pp.353. [2168.]

Macedonia

HRISTO G. ANDONOVSKI, Прилог кон библио-
графијата по археологијата на Македонија.
Институт за национална историја: Скопје
1953. pp.62. [476.]

Mediterranean

KAZIMIERZ MAJEWSKI and HALINA BITTNER,

Archaeology

Materiały do bibliografi archeologii śródziem-
nomorskiej w Polsce za lata 1800–1950. Biblioteka
archeologiczna (no.4): Warszawa &c. 1952.
pp.vii.91. [2093.]

WESTERN MEDITERRANEAN. Council for old world
archaeology: COWA surveys bibliographies:
Cambridge, Mass. 1961 &c.
in progress.

EASTERN MEDITERRANEAN. Council for old world
archaeology: COWA surveys bibliographies:
Cambridge, Mass. 1961 &c.
in progress.

Mexico

HERMANN BAYER, Succinta bibliografía siste-
mática de etnografía y arqueología mexicana.
Universidad nacional de México: Facultad de
altos estudios: México 1923. pp.40. [400.]

Near east

BIBLIOGRAPHIE analytique de l'assyriologie et de
l'archéologie du proche-orient. Section A.
L'archéologie. Leyde.
 i. 1954–1955. Par L. Vanden Berghe et H. F.
 Mussche. 1956. pp.xv.131. [750.]
 ii. 1956–1957. 1960. pp.x.178. [1750.]

Archaeology

Netherlands

A. A. VAN RIJNBACH, Repertorium van tijd-
schriftartikelen betreffende nederlandsche monu-
menten van geschiedenis en kunst, 1901–1908.
Nederlandsch oudheidkundige bond: Leiden
[1909]. pp.56. [1500.]

—— Supplements. Alkmaar [Den Haag].

 i. 1909. pp. 12. [200.]

 ii. 1910.

 iii. 1911.

 iv. 1912–1913. Door E. J. Haslinghuis. pp.19.
 [600.]

 v. 1914. pp.12. [350.]

 vi. 1915. pp.11. [300.]

 vii. 1916. Door Frans Vermeulen. pp.17.
 [500.]

 viii.

 ix.

no more published.

REPERTORIUM betreffende nederlandsche monu-
menten van geschiedenis en kunst (voornamelijk
van tijdschriftartikelen). Nederlandsche oud-
heidkundige bond: 's-Gravenhage.

 i. 1901–1934. [Edited by Dirk Petrus Marius
 Graswinckel]. 1940. pp.iii–xx.582.
 [16,000.]

Archaeology

ii. 1935–1940. 1943. pp.xxiii.294. [7000.]
iii. 1941–1950. 1962. pp.xv.492. [11,000.]

Pacific

PACIFIC islands. Council for old world archaeology: COWA surveys bibliographies: Cambridge, Mass. 1961 &c.
in progress.

Palestine

MOSHEH STEKELIS, Prehistory in Palestine. A bibliography. Jerusalem 1932. pp.[v].45. [379.]

Peru

H[ANS] HORKHEIMER, Guía bibliográfica de los principales sitios arqueologicos del Peru. Universidad nacional mayor de San Marcos: Biblioteca central: Lima 1950. pp.181–234. [250.]

Poland

L[EON] J[AN] ŁUKA, Bibliografia archeologii polskiej za lata 1944–1954. Instytut historii kultury materialnej PAN: [Warsaw 1956]. pp.[iii].v.163. [1564.]*

Romania

NICOLAE STOLCESCU, Repertoriul bibliografic al

monumentelor feudale din Bucureşti. [Bucharest 1961]. pp.363. [5000.]

Russia

V[LADIMIR] I[ZMAILOVICH] MEZHOV, Археологія Русская въ періодѣ времени отъ 1859 г. до 1868 г. включительно. Библіографическій указатель. Санктпетербургъ 1873. pp.iv. 263. [1500.]
first published in annual instalments under the title of Библіографическій указатель русской археологической литературы.

каталог изданий Государственной академии истории материальной культуры (ГАИМК) и изданий находящихся на складе ГАИМК. Ленинград [1931]. pp.84.

HENRY FIELD, List of publications on soviet archaeology. Miami 1952. ff.8. [101.]*
limited to works published in 1936–1952.

N. A. VINBERG, T. N. ZADNEPROVSKAYA and A. A. LYUBIMOVA, Советская археологическая литература. Библиография 1941–1957. Академия наук СССР: Институт истории материальной культуры: Москва &c. 1959. pp.775. [8765.]

Archaeology

EUROPEAN RUSSIA. Council for old world archaeology: COWA surveys bibliographies: Cambridge, Mass. 1961 &c.

in progress.

Scandinavia

E[MIL] VEDEL, Oversigt over den danske literatur om nordens forhistoriske arkæologi indit og med aaret 1904. Kjøbenhavn 1905. pp.[iv].164. [3000.]

SCANDINAVIA. Council for old world archaeology: COWA surveys bibliographies: Cambridge, Mass. 1961 &c.

in progress.

Scotland

[FREDERIC KENT], Catalogue of the library of the Glasgow archæological society. Glasgow 1919. pp.viii.140. [1750.]

Slavonic

VĚSTNIK slovanských starožitností. [Edited by] L[ubor G.] Niederle. Praha.

 i. 1898. pp.135. [300.]
 ii. 1899. pp.133.15. [453.]
 iii. 1899. pp.84.42. [175.]
 iv. 1900. pp.96. [272.]

Archaeology

Spain

GREGORIO CALLEJO Y CABALLERO, Índice general bibliográfico de la obra intitulada Museo español de antigüedades. Madrid 1889. pp.147. [350.]

CARLOS RAMOS RUIZ, Catálogo de la documentación referente a los archivos, bibliotecas y museos arqueológicos que se custodia en el archivo del Ministerio de educación nacional. Cuerpo facultativo de archiveros, bibliotecarios y arqueólogos: Madrid 1950. pp.iii–xvi.451. [5000.]*

D[OMINGO] FLETCHER VALLS and E. PLA BALLESTER, Repertorio do bibliografía arqueológica valenciana. Instituto Alfonso el magnánimo [vol.ii: Instituto de arqueología Rodrigo Caro: Serie de trabajos varios (no.14)]: Valencia 1951–1954. pp.[iii].146+[iii].99. [1500.]

PUBLICACIONES sobre prehistoria y edad antígua de la provincia de Lérida y comarcas adyacentes. Consejo superior de investigaciones científicas: Instituto de estudios ilerdenses: Lérida 1955. pp.19. [75.]

FRANCISCO FIGUERAS PACHECO and DOMINGO FLETCHER VALLS, Bibliografía arqueólogica de la provincia de Alicante. Comisión provincial de

monumentos históricos y artísticos. Alicante 1958. pp.316. [858.]

printed on one side of the leaf.

Sweden

[JOHAN HADORPH], Catalogus librorum qui in historia & antiquitatibus patriæ sub imperio clementissimi regis nostri dn. Caroli XI. publicati sunt, et, vel jam editioni parati, vel adhuc summâ curâ elaborantur ab assessoribus Collegii antiquitatum. Stockholm 1690. pp.29. [100.]

the titles are given in latin and swedish.

CARL GUST. WARMHOLTZ, Bibliotheca historica sveo-gothica. . . . Tredje delen, Som innehåller de böcker och skrifter, hvilka angå Sveriges antiquiteter. Stockholm 1787. pp.[ii].viii.254.[viii]. [403.]

OSCAR MONTELIUS, Bibliographie de l'archéologie préhistorique de la Suède pendant le XIXᵉ siècle. [Svenska fornminnes-förening:] Stockholm 1875. pp.[iii].106. [311.]

OSCAR MONTELIUS, Sveriges archeologiska literatur. Stockholm [printed].

 1875–1876. pp.8 [125.]
 1877. pp.6. [100.]
 1878–1879. pp.8. [125.]
 1880–1881. pp.7. [100.]

Archaeology

Turkey

HALİL ETEM [EDHEM], İstambulda iki irfan evi.
Alman ve Fransız arkeologi enstitüleri ve bunların
neşriyatı. İstanbul müzeleri neşriyatı (no.xiv):
İstanbul 1937. pp.34. [22.]

ARIF MÜFID MANSEL, Türkiyenin arkeoloji, epi-
grafi ve tarihî coğrafyası için bibliografya. Türk
tarih kurumu: Yayınları (12th ser., vol.i): Ankara
1948. pp.xvi.616. [7500.]

United States

LIST of references on the cliff dwellers and
archaeological remains of Colorado. Library of
Congress: Washington 1904. ff.10. [55.]*

CLAUDE E. SCHAEFFER and LEO J. ROLAND, A
partial bibliography of the archaeology of Penn-
sylvania and adjacent states. Pennsylvania histor-
ical commission: Harrisburg 1941. pp.[vi].45.
[800.]*

ROY G[IFFORD] PIERCE, Preliminary biblio-
graphical list of articles, books and references to
Virginia Indians, with particular emphasis on
archeology. Archeological society of Virginia:
[Richmond 1944]. ff.9. [125.]*

Archaeology

4. Miscellaneous

[CHARLES LENORMANT], Résumé des publications archéologiques de m. Ch. Lenormant. 1849. pp.8. [60.]

F. A. LEFEBVRE [and A. DE ROSNY], Notice sur les travaux historiques et archéologiques de m. le chanoine Haigneré. Société académique de l'arrondissement de Boulogne-sur-Mer: Mémoires (vol.xvii): Boulogne [1896]. pp.140. [575.]

F. BLANQUART, Bibliographie des travaux historiques et archéologiques de monseigneur Julien Loth, 1862–1913. Rouen 1914. pp.90. [375.]

GIUSEPPE FERRETTO, Note storico-bibliografiche di archeologia cristiana. Città del Vaticano 1942. pp.iii–xi.485. [1500.]

CARLOS RAMOS RUIZ, Catálogo de la documentación referente a los archivos, bibliotecas y museos arqueológicos, que se custodia en el archivo del Ministerio de educación nacional. Cuerpo facultativo de archiveros, bibliotecarios y arqueologos: Madrid 1950. pp.xvi.451. [4000.]

RUTHERFORD J[OHN] GETTENS and BERTHA M. USILTON, Abstracts of technical studies in art and archeology 1943–1952. Freer gallery of art: Occa-

sional papers (vol.2, no.2): Washington 1955. pp.viii.408. [1399.]

[ERNEST] R[AYMOND] CHEVALLIER, Bibliographie des applications archéologiques de la photographie aérienne. Politecnico di Milano: Fondazione ing. C. M. Lerici: [Milano 1957]. pp.viii.44. [513.]

—— [another edition]. Bulletin d'archéologie marocaine (vol.ii, supplement): Casablanca 1959. pp.68. [718.]

PAUL GAUDEL, Bibliographie der archäologischen konservierungstechnik. Berliner blätter für vor- und frühgeschichte (vol.8): Berlin 1960. pp.212. [1000.]

Architecture.

1. *Periodicals*

LIST of periodicals in the Science library dealing with building construction and architecture. Science library: Bibliographical series (no.364): 1937. ff.6. [162.]*

Architecture

PAN AMERICAN magazines relating to architecture, art and music. Pan american union: Columbus memorial library: Washington 1942. ff.[i].13. [100.]*

2. General

ANGELO COMOLLI, Bibliografia storico-critica dell' architettura civile ed arti subalterne. Roma 1788–1792. pp.xiv.332+iv.380+[iv.]316+iv. 320. [750.]

CATALOGUE of the library. Royal institute of british architects: 1838. pp.74. [300.]
— [another edition]. [1846]. pp.vii.201. [1500.]
— [another edition]. Catalogue of the printed books and manuscripts in the library of the Royal institute of british architects. 1865. pp.iv.184. [6500.]
— [another edition]. The library catalogue. 1889. pp.viii.318. [7500.]
— [another edition]. Catalogue of the Royal institute [&c.]. [By H. V. Molesworth Roberts]. 1937–1938. pp.x.1138+xiii.516. [25,000.]

CATALOGUE de la bibliothèque. Société centrale des architectes: 1850. pp.7. [40.]
— — [another edition. By Frantz Jourdain]. 1898. pp.100. [1150.]

LOUIS BOUCHARD [HUZARD], Bibliographie. Ouvrages publiés jusqu'à ce jour sur les constructions rurales et sur la disposition des jardins. 1860. pp.[iv].826–876. [275.]

50 copies printed.

—— Deuxième édition. 1870. pp.[iv].947–1048. [500.]

90 copies printed; this work also forms part of the author's Traité des constructions rurales.

KATALOG der gebundenen werke der bibliothek des Architekten- & ingenieur-vereins für das königreich Hannover. Hannover 1864. pp.52. [500.]

— [another edition]. 1877. pp.vii.101. [1750.]

—— Jahres-nachtrag.

1877. pp.20. [300.]

1878. pp.19. [275.]

F[EDOR ANDREEVICH] KLAGES, Каталогъ книгъ и изданій библіотеки Императорской академіи художествъ по части архитектуры. Санктпетербургъ 1873. pp.47. [141.]

KATALOG der bibliothek des Oesterreichischen ingenieur- und architekten-vereins in Wien. Wien 1881. pp.[vi].177. [3500.]

— [another edition]. 1900. pp.xv.418. [9000.]

TEMISTOCLE MOZZANI, Repertorio tecnico-bibliografico ad uso dell' ingegnere-architetto. Roma 1887. pp.[iii].128. [7000.]

[A. MICHAËLS], Katalog der bibliothek des Architekten-vereins zu Berlin. Berlin 1887. pp.xii.380. [4478.]

— — Nachtrag.

 i. 1888. pp.40. [400.]

 ii. 1889. pp.23. [200.]

 iii. 1890.

 iv. 1891. pp.26. [200.]

 v. 1892. pp.28. [150.]

 vi. 1893. pp.24. [125.]

 vii. 1894. pp.27. [125.]

 viii. 1896. pp.39. [200.]

 ix. 1897. pp.34. [200.]

 x.

 xi. 1904. pp.76. [600.]

каталогъ библіотеки Московскаго архитектурнаго общества. Москва 1888. pp.100. [750.]

CATALOGUE of the J. Morgan Slade library and other architectural works in the Apprentices' library. General society of mechanics and tradesmen: New York 1892. pp.iv.24. [1750.]

HERBERT BATSFORD, Reference books on architecture & decoration. [1894]. pp.24. [60.]
privately printed.

CATALOGUE of the books relating to architecture construction and decoration. Public library: Subject catalogue (no.10): Boston [Mass.] 1894. pp.[iii].150. [6500.]
— Second edition. [By Mary Harris Rollins]. 1914. pp.x.535. [16,500.]

HAND-LIST of books on architecture in the reference department, William Brown street. Free public libraries: Liverpool 1894. pp.[iv].51. [1000.]
— Continuation. Hand-list of books on the building trades. 1896. pp.[vi].53–81. [650.]
— Supplement. 1902. pp.[iv].18. [350.]

[HARRIET BEARDSLEE PRESCOTT *and others*], Catalogue of the Avery architectural library. Columbia college: New York 1895. pp.xvii.1139. [12,500.]

КАТАЛОГЪ библіотеки Института инженеровъ путей сообщенія императора Александра 1. ... Гражданская архитектура. С.-Петербургъ 1895. pp.[iii].93. [676.]

CATALOGUE of the books in the library of the

Architectural association. 1895. pp.[v].ff.160. [1250.]

CATALOGUE of books in library. Manchester society of architects: Manchester 1895. pp.[iii].81. [400.]
pages 44–81 are blank.

SUBJECT list of works on architecture and building construction, in the library of the Patent office. Patent office library series (no.12＝Bibliographical series, no.9): 1903. pp.164. [1344.]

THE ARCHITECTURAL index. New York.
 i. January–February 1903. [Edited by Joseph A. F. Cardiff]. pp.29. [500.]
 ii. [*not published*].
 iii. January–March 1904. pp.24.22.20. [2000.]
no more published.

[ERNEST MARRIOTT], A list of works in the Portico library on or relating to architecture. Portico lists (no.1): Manchester 1905. pp.15. [200.]

BYGNINGSKUNST. Fortegnelse over bøger og danske tidsskriftafhandlinger verdrørende bygningskunsten og dens historie. Statsbiblioteket: Smaa bogfortegnelser (no.i): Aarhus 1906. pp.24. [500.]

HENRY GUPPY and GUTHRIE VINE, A classified

catalogue of the works on architecture and the allied arts in the principal libraries of Manchester and Salford. Joint architectural committee: Manchester 1909. pp.xxv.310. [2750.]

RUDOLF DIRCKS, Catalogue of loan library. Royal institute of british architects: 1909. pp.iv.84. [2500.]

CATALOGUE of books on the building trades and architecture in the Sunderland public libraries. [Sunderland] 1910. pp.vi.21. [350.]

FERNANDO ARIÑO, Catálogo del donativo de [Juan C.] Cebrián. Escuela superior de arquitectura de Madrid: Biblioteca: Catalogos (vol.ii): Madrid 1917. pp.xxxi.560. [3000.]

CATALOGUE of books on architecture and the fine arts in the Gordon Home Blackader library and in the McGill university library. McGill university: Publications (7th ser., no.4): Montreal 1922. pp.3–65. [2000.]
—— Second . . . edition. A catalogue of books on art and architecture [&c.]. 1926. pp.[ii].193. [4000.]

ARTHUR STRATTON, A short bibliography of architecture for the use of teachers of history and

others. Historical association: Leaflet (no.54): 1923. pp.16. [250.]

LIST of books on architectural design. Library of Congress: Washington 1923. ff.3. [39.]*

LIST of books recommended to students. Royal institute of british architects: [1923]. pp.11. [300.]

— [another edition]. Selected list of books on architectural subjects. 1931. pp.30. [800.]

LIST of books approved by the Council of the R.i.b.a. . . . for the use of architects and their pupils. 1926. pp.[3]. [75.]

SELECT list of books on architecture in the reference and lending libraries. Sheffield 1928. ff.[i].9. [250.]*

ARCHITECTURE. Books in the Bristol public libraries. [Bristol 1932]. pp.32. [600.]

CATÁLOGO-GUÍA de la sección arquitectura. Universidad de Buenos Aires: Facultad de ciencias exactas, físicas y naturales: Biblioteca: Buenos Aires 1934. pp.iii–vii.75. [750.]*

ARCHITECTURE. A selected list of non-technical books . . . compiled by the Royal institute of british architects. Seventh edition. [National book council:] Book list (no.34): 1935. pp.4. [125.]

— Eighth edition. 1941. pp.[4]. [125.]

LIST of books recommended to students preparing for the intermediate examination of the R.i.b.a. [1938]. pp.[3]. [100.]

READERS' guide to books on architecture and building construction. Library association: County libraries section: 1938. pp.[ii].22. [600.]

Z. D. VINOGRAD, Библиография по архитектуре. Указатель непериодических изданий на русском языке. Под редакцией арх. Н. Е. Роговина. Москва 1940. pp.196. [5085.]

ARCHITECTURE and architectural engineering. Library of Congress: Washington 1944. ff.4. [25.]★

ИЗДАТЕЛЬСТВО Академии архитектуры СССР. Аннотированный каталог, 1933–1944. Москва [1945]. pp.168. [300.]

CATÁLOGO de la biblioteca. Colegio oficial de arquitectos de Cataluña y Baleares: [Barcelona 1950]. pp.[vii].172. [8000.]

THE ARCHITECTURAL index. [Denver, Col.].★
 1950. Compiled . . . by Erwin J. Bell. pp.[ii].
 32. [1000.]
 1951.
 1952. pp.33. [1000.]
 1953. pp.44. [2000.]

1954. pp.39. [1200.]
1955. pp.49. [1500.]
1956. pp.59. [1800.]
1957. pp.53. [1500.]
1958. pp.51. [1500.]
1959. pp.56. [1700.]
1960. pp.61. [1800.]
1961. pp.62. [1800.]
1962. pp.60. [1800.]
in progress.

TASCHENBUCH der internationalen bauliteratur. Deutsches bauzentrum: Dokumentationsstelle für bautechnik [Stuttgart]: Berlin 1957. pp.384. [3500.]

CATALOG of the Avery memorial architectural library of Columbia university. Boston 1958.

i. A–Callot. pp.[iii].1926. [40,446.]
ii. Callwey–Falisci. pp.[iii].1927–3852. [40,446.]
iii. Falk–Joannes. pp.[ii].3853–5782. [40,530.]
iv. Joao–Ott. pp.[ii].5783–7710. [40,454.]
v. Ottaviani–Scotti. pp.[ii].7711–9610. [39,900.]
vi. Scottish–Z. pp.[ii].9611–11534. [40,425.]
this is a photographic reproduction of catalogue cards; the figures in square brackets represent these cards.

ARCHITECTURE. Surrey county library: Book list (no.3): [Esher] 1958. pp.[ii].19. [400.]*

ARCHITECTURE, drafting, engineering and refrigeration. Pacific air forces: PACAF basic bibliographies: San Francisco] 1958.*
— [another edition]. Architecture, building, and engineering. Prepared by Mary K. Haskin. 1960. pp.[ii].iv.41. [250.]*

LISTA de adquisiciones. Universidad del Valle: Facultad de arquitectura: Biblioteca: Cali 1959 &c.*
in progress?

LAURENCE HALL FOWLER and ELIZABETH BAER, The Fowler architectural collection of the Johns Hopkins university. Catalogue. Evergreen house foundation: Publication (no.1): Baltimore 1961. pp.xvi.383. [448.]

АРХИТЕКТУРА. Государственная публичная библиотека имени М. Е. Салтыкова–Щедрина: [Leningrad 1961]. pp.12. [50.]

HANNA LASCH, Architekten-bibliographie. Deutschsprachige veröffentlichungen 1920–1960. Leipzig 1962. pp.216. [3702.]

ÍNDICE bibliográfico del Centro de investigación y de estudios avanzados. Sección 2ª Inge-

niería y arquitectura. Instituto politécnico nacional: México 1962 &c.

in progress.

AVERY index to architectural periodicals, Columbia university. Boston 1963.

 i. A–Bat. pp.[iv].675. [23,500.]
 ii. Bau–Chim. pp.[ii].681. [23,500.]
 iii. Chin–Cz. pp.[ii].651. [23,500.]
 iv. Da–Faz. pp.[ii].684. [23,500.]
 v. Fe–Hef. pp.[ii].662. [23,500.]
 vi. Heg–Kap. pp.[ii].673. [23,500.]
 vii. Kar–Mas. pp.[ii].663. [23,500.]
 viii. Mat–Of. pp.[ii].696. [23,500.]
 ix. Og–Rec. pp.[ii].662. [23,500.]
 x. Red–Shep. pp.[ii].670. [23,500.]
 xi. Sher–Twel. pp.[ii].688. [23,500.]
 xii. Twen–Z. pp.[ii].238. [7000.]

this is a photographic reproduction of catalogue cards; the figures in square brackets represent these cards.

3. *Specific periods*

A LIST of books and pamphlets in the National art library . . . illustrating architecture of the renaissance and later periods, to the close of the 18th century. South Kensington museum [*afterwards:* Victoria and Albert museum]: 1888. pp.vi.66. [1000.]

Architecture

EUGÈNE MÜNTZ, La bibliothèque Lesoufaché à l'École des beaux-arts. 1. Le XVᵉ et le XVIᵉ siècle. 1892. pp.8. [75.]

JEAN HUBERT, L'architecture religieuse du haut moyen âge en France. Plans, notices et bibliographie. École pratique des hautes études: Collection chrétienne et byzantine: 1952. pp.[ii].97. [1000.]

ERNEST ALLEN CONNALLY, Printed books on architecture, 1485–1805. University of Illinois: Adah Patton memorial fund: Urbana 1960. pp.39. [38.]
an exhibition catalogue.

4. Countries &c.

Africa, south

ELIZABETH O. HEWITT, A bibliography of architecture in south Africa, in which is included a selection of books on south african furniture, housing, practical construction and building materials, and town planning. University of Cape Town: School of librarianship: Bibliographical series: [Capetown] 1945 [1950]. ff.x.33. [239.]*

China and Japan

BRIEF list of references on japanese and chinese

architecture. Library of Congress: Washington 1925. ff.4. [44.]*

Egypt

MIRPAH G. BLAIR, History of architecture. Part I: Ancient egyptian architecture. Public library: Special reading list (no.7): Cincinnati 1901. pp.4. [60.]

France

[MARQUIS A. R. DE VOYER D'ARGENSON DE PAULMY and A. G. CONTANT D'ORVILLE], De la lecture des livres françois. Des livres écrits en françois au seizième siècle, qui traitent de l'architecture, & des progrès de cet art jusqu'au dix-septième. Mélanges tirés d'une grande bibliothèque (vol.Gg): 1782. pp.viii.372. [50.]

É[TIENNE] L[ÉON] G[ABRIEL] CHARVET, Lyon artistique. Architectes. Notices biographiques et bibliographiques. Lyon 1899. pp.[ii].xiv.436. [2000.]

Great Britain

ARTHUR H[ENRY] LYELL, A bibliographical list descriptive of romano-british architectural remains in Great Britain. Cambridge 1912. pp.xii. 156. [6000.]

BOOKS on art, architecture and archæology

published during 1936. pp.16. [250.]
limited to works published in Great Britain.

JOHN ARCHIBALD, Architectural heritage and its social and cultural backgrund. National book council: Book list (no.194): 1942. pp.12. [400.]

Islam

K[EPPEL] A[RCHIBALD] C[AMERON] CRESWELL, A provisional bibliography of the muhammadan architecture of India. Bombay 1922. pp.[ii].81–108. 165–179. [750.]

K. A. C. CRESWELL, A provisional bibliography of the moslem architecture of Syria and Palestine. [*s.l.* 1927]. pp.69–94. [300.]

K. A. C. CRESWELL, A bibliography of muslim architecture in north Africa (excluding Egypt). Hespéris (vol.xli, supplement): 1954. pp.67. [750.]

K[EPPEL] A[RCHIBALD] C[AMERON] CRESWELL, A bibliography of the architecture, arts and crafts of Islam to 1st Jan. 1960. [Cairo] 1961. pp.xxiv.coll. 1330.pp.xxv. [15,000.]

Russia

A.VLADIMIRSKY, Архитектурная книга за

xv лет. Академия архитектуры СССР.
Москва 1949. pp.436. [500.]

РУССКИЕ архитекторы и строители. Анно-
тированный указатель литературы. Госу-
дарственная библиотека СССР им. В. И. Ле-
нина: Что читать о выдающихся деятелях
русской науки и техники (no.4): Москва
1952. pp.159. [300.]

[ELIZABETA PETROVNA FEDOSEEVA], Описание
архитектурных материалов, Москва и мос-
ковская область. Государственная... пу-
бличная библиотека имени М. Е. Сальтыко-
ва-Щедрина: Труды отдела рукописей: Ле-
нинград 1956. pp.88. [250.]

Spain

FLORENTINO ZAMORA LUCAS and EDUARDO
PONCE DE LEÓN [Y FREYRE], Bibliografía española
de arquitectura (1526–1850). Asociación de libre-
ros y amigos del libro: Publicaciones (vol.iii):
Madrid 1947. pp.3–206. [293.]
200 copies printed.

Switzerland

BERTHOLD HAENDCKE, Architectur, plastik und

Architecture

malerei. Centralkommission für schweizerische landeskunde: Bibliographie der schweizerischen landeskunde (section V.6.a–c): Bern 1892. pp.ix. 100. [Architecture: 600.]

United States

LIST of references on colonial architecture. Library of Congress: Washington 1918. ff.4. [16.]*

LIST of references on historic buildings in the United States. Library of Congress: Washington 1919. ff.4. [44.]*

COLONIAL architecture and other early american arts. Carnegie library: Pittsburgh 1926. pp.28. [250.]

TALBOT F. HAMLIN, A bibliography of american architecture. [Columbia university: Avery Library: New York c.1935]. ff.[i].9. [100.]*

HENRY RUSSELL HITCHCOCK, A tentative check list of books on architecture published in America before 1895. [s.l. 1937]. ff.[iii].27. [1000.]*
— — American architectural books. A list of books, portfolios and pamphlets . . . published in America before 1895. Third revised edition. Minneapolis 1946. pp.viii.130. [1461.]

A LIST of published writings of special interest in the study of historic architecture of the Mississippi Valley. Second edition. Historic american buildings survey: St. Louis 1940. ff.[iii].29. [350.]*

CONNECTICUT houses. A list of manuscript histories. Connecticut state library: Bulletin (no.17): Hartford 1942. ff.[i].47. [904.]*

SARO JOHN RICCARDI, Pennsylvania dutch folk art and architecture. A selective annotated bibliography. Public library: New York 1942. pp.15. [150.]

FRANK J[OHN] ROOS, Writings on early american architecture. An annotated list of books and articles on architecture constructed before 1860 in the eastern half of the United States. [Ohio] State university, Columbus: Graduate school studies: Contributions in fine arts (no.2): Columbus 1943. pp.ix.271. [2763.]

W. LANE VAN NESTE and VIRGIL E. BAUGH, Preliminary inventory of the records of the Public buildings service. National archives: Preliminary inventories (no.110): Washington 1958. pp.v.108. [large number.]

Architecture

5. Miscellaneous

LIST of references on municipal architecture. Library of Congress: Washington 1908. ff.5. [31.]*

PROFESSOR architect Leopold Oelenheinz. Verzeichnis der wichtigeren werke. Coburg [1917–1926]. pp.16. [400.]

[TALBOT F. HAMLIN], Theories of architecture, 19th and 20th centuries. [Columbia university: Avery library: New York 1934]. ff.5. [100.]*

[R. V. GALINSKY], Каталог, книги и журналы. [Издательство Всесоюзной академии архитектуры]. Москва 1936. pp.112. [50.]

BOOK list. Council for education and appreciation of physical environment: [1943]. pp.4. [35.]

— [another edition]. [1944]. pp.4. [45.]

THOMAS JEFFERSON and architecture. A list of books and articles in the library of Virginia. Alderman library: Charlottesville 1953. ff.3. [30.]*

THOMAS N. MAYTHAM, Henri Labrouste, architect: a bibliography. American association of architectural bibliographers: Publication (no.5): Charlottesville, Va. 1955. ff.[i].5. [29.]*

A LIST of books and articles on vernacular archi-

tecture. Vernacular architecture group: [1956]. ff.[10]. [100.]*

— List no.2. Compiled by J. T. Smith. 1957. ff.[13]. [150.]*

— List no.3. 1958. ff.[15.] [200.]*

— List no.4. 1960. ff.[19]. [200.]*

WILLIAM B[AINTER] O'NEAL, A checklist of writings on Thomas Jefferson as an architect. American association of architectural bibliographers: Publication (no.15): [Charlottesville] 1959. pp.18. [150.]

RECENT publications on theatre architecture. University of Pittsburgh: Department of speech [and theatre arts]: Pittsburgh 1960 &c.

in progress; details of this work are entered under Drama, below.

Towns, town and regional planning.

1. Bibliographies, 136.
2. Periodicals, 136.
3. General, 136.

1. *Bibliographies*

SHORT list of general bibliographies on town and country planning. Ministry of housing and local government: Library: Bibliography (no.76): [1951]. pp.4. [35.]*

2. *Periodicals*

LIST of current periodicals in the Science library dealing with town and garden planning. Science library: Bibliographical series (no.381): 1938. ff.2. [35.]*

3. *General*

CHECK list of references on city planning. Special libraries association: Special libraries (vol.iii, no.5): Indianapolis 1912. pp.61–123. [2500.]

CITY planning and beautifying. A selected list of books and of references to periodicals. Public

library: Brooklyn [1912]. pp.16. [225.]

SELECT list of works relating to city planning and allied topics. Public library: New York 1913. pp.35. [600.]

INVENTAIRE des documents relatifs à l'aménagement et à l'extension des villes et conservés au Musée social. Préfecture du département de la Seine: Commission d'extension de Paris: 1913. pp.54. [350.]

[MARY H. ROLLINS], Catalogue of books relating to architecture. . . . Second edition, with an additional section on city planning. Public library: Subject catalogue (no.10): Boston 1914. pp.x.535. [town planning: 2000.]

THEODORA KIMBALL, Classified selected list of references on city planning. National conference on city planning: Boston 1915. pp.48. [1200]

LIST of references on landscape art and gardening (titles taken from the A.L.A. catalogue). Library of Congress: Washington 1916. ff.5. [60.]★
— Additional references. 1932. ff.3. [30.]★

LIST of recent references on garden cities. Library of Congress: Washington 1916. ff.5. [63.]★

BRIEF list of references on city planning. Library of Congress: Washington 1917. ff.4. [42.]*

BRIEF list of references on landscape gardening, planting of trees, shrubs and flowers. Library of Congress: Washington 1919. ff.4. [38.]*

MARY J. HIRST, City planning. Reading list (no.14): Public library: Cincinnati 1921. pp.20. [175.]

LIST of recent references on city planning. Library of Congress: [Washington] 1922. ff.12. [13]. [129.]*

THEODORA KIMBALL, Manual of information on city planning and zoning, including references on regional, rural, and national planning. Cambridge [Mass.] 1923. pp.xi.188. [2250.]
—— Theodora Kimball Hubbard and Katharine McNamara, Planning information up-to-date. A supplement, 1923–1928, to Kimball's Manual of information. 1928. pp.viii.103. [1200.]
—— Katharine McNamara, Bibliography of planning, 1928–1935. A supplement to Manual of planning information. Harvard city planning studies (vol.x): 1936. pp.viii.232. [4000.]

[FRANK ALBERT WAUGH], Country planning.

Town Planning

Russell Sage foundation: Library: Bulletin (no.67): New York 1924. pp.4. [75.]

BOOKS on town planning. A reference collection on view in the Blackader library of architecture. McGill university: Publications (ser.vii: library, no.7): Montreal 1926. pp.20. [300.]

LIST of books on zoning. Library of Congress: Washington 1926. ff.4. [41.]*

BIBLIOGRAPHY on housing, town planning and garden cities. Prepared by the Garden cities and town-planning association. Revised edition. [National book council: Book list] (no.9): 1927. pp.4. [100.]

[G. ERIC HASLAM], Books on housing, town planning and regional survey in the reference library. Public libraries: Occasional lists (n.s. no.1): Manchester 1930. pp.8. [200.]

BOOKS of the month. Harvard university: Library of the school of landscape architecture and city planning [*afterwards:* of the departments of landscape architecture and regional planning]: Cambridge 1932 &c.*

FLORENCE S[ELMA] HELLMAN, List of references on regional, city and town planning, with special

reference to the Tennessee valley project. Library of Congress: [Washington] 1933. pp.46. [423.]★

CITY planning. A selective bibliography of material on the Oregon state library. [Salem 1934]. ff.8.pp.9–10. [270.]★

PLANNING bibliography. Selected list of books, pamphlets, reports and articles dealing with national, state, regional and city planning, and related subjects in the field of public administration. American society of planning officials: [Chicago 1939]. ff.13. [150.]★

ZONING. A list of references from state planning board reports. National resources planning board: Library: [Washington] 1941. ff.[i].5. [50.]★

BIBLIOGRAPHY of reports by state and regional planning organization. National resources planning board [National resources committee]: Washington 1941 &c.★

ABSTRACTS of selected material on postwar housing and urban redevelopment. National housing agency: [Washington] 1942 &c.

REBUILDING Britain. A selected list of books on town and country planning. Public libraries: Bristol 1943. pp.20. [350.]

[HONORA] KATHERINE MCNAMARA, A selected list of recent references on urban rehabilitation in the United States. Harvard university: Library of the departments of landscape architecture and regional planning: Cambridge 1943. ff.9. [125.]*

[HONORA] KATHERINE MCNAMARA, Landscape architecture. A selected list. Harvard university: Library of the departments of landscape architecture and regional planning: Cambridge 1943. ff.7. [100.]*

ANDREW GRANT bequest. Abstracts of theses. Edinburgh college of art: [Edinburgh] 1943 &c. *details of this work are entered under Edinburgh college of art, above; not wholly devoted to town planning.*

F. H. FENTON, Town and country planning. A book list. Public libraries: Tottenham 1944. pp. [ii].14. [300.]

TOWN and country planning. A select list of books in the Bath municipal library. Bath 1944. pp.8. [150.]

TOWARD a better city. A brief reading list. Public library: Boston [1944]. pp.[4]. [29.]

TOWN and country planning bill, 1947. House

of commons: library: Bibliography (no.17): [1947]. ff.13. [85.]*

F. J. OSBORN, Town and country planning. National book league: Reader's guide: 1947. pp. 12. [60.]

MARINA EMILIANI SALINARI, Bibliografia degli scritti di geografia urbana (1901–1944). Università di Roma: Istituto di geografia antropica: Memorie di geografia antropica (vol.ii, no.2): Roma 1948. pp.[vi].91. [1955.]

MAURICE FRANK PARKINS, City planning in Soviet Russia. An interpretative bibliography. Harvard university: Russian research center: Cambridge 1949. ff.[i].xvi.pp.198. [1000.]*

TABLE chronologique des circulaires. Ministère de la reconstruction et de l'urbanisme: 1949. pp.94. [1000.]

H[ARRY] CROSSLEY and R[ICHARD] N[EWBURGH] HUTCHINS, A referencer to planning law and practice. [1950]. pp.xxiv. [100.]

SAMUEL SPIELVOGEL, A selected bibliography on city and regional planning. Washington 1951. pp.[iii].ix.276. [2182.]

OPEN spaces. Revised. Ministry of housing and

local government: Library: Bibliography (no.95): [1951]. ff.12+11. [242.]*

BARBARA J. HUDSON, The urban fringe problem: a bibliography. University of California: Bureau of public administration: Berkeley 1952. ff.14. [150.]*

BULLETIN [mensuel] de documentation et d'information. Ministère de la reconstruction et de l'urbanisme: Service de la documentation.
 i. 1952. pp.115. [500.]
 ii. 1953. pp.72.49.65.97.77. [1500.]
no more published?

PRZEGLĄD bibliograficzny zagadnień mieszkaniowych. Opracowany przez Dział dokumentacji Instytutu budownictwa mieszkaniowego. Warszawa 1952 &c.
in progress.

J[OSEF] UMLAUF, Deutsches schrifttum zur stadtplanung. Nachweis bis anfang 1950. Düsseldorf 1953. pp.152. [1750.]

SELECTED list of books, pamphlets and periodicals in english on community organization and development. United nations: [New York] 1953. pp.[ii].24. [250.]*

T[HOMAS] B[ERNARD] OXENBURY, Bibliography of publications referring to the development of country towns in Great Britain. Town and country planning association: Country towns committee: [1953]. pp.[i].7. [100.]

BIBLIOGRAFÍA de la vivienda de interés social en Colombia en 1953. Recogida por el Servicio de intercambio científico. Centro interamericano de vivienda: Serie bibliografía (no.1): Bogotá 1954. pp.[iii].37. [500.]*

NEW towns. Ministry of housing and local government: Library: Bibliography (no.65): [1954]. ff.24. [375.]*

TOWN and country planning. [Revised edition]. A short list of publications. Ministry of housing and local government: Library: Bibliography (no.70): [1954]. ff.6. [78.]*

LIST of published approved development plans. Ministry of housing and local government: Library: Bibliography (no.97): [1954]. ff.5. [31.]*

DENSITY of development. Ministry of housing and local government: Library: Bibliography (no.103): [1954]. ff.6. [45.]*

FERDINAND BOYER, L'histoire des beaux arts et

de l'urbanisme dans l'Italie napoléonienne d'après les ouvrages parus depuis 1900. Livorno [printed] 1955. pp.12. [80.]

URBAN renewal bibliography. American council to improve our neighbourhoods: 1955.
— Supplement. Publications relating to urban renewal. Public library: Washington, D.C.*
[i]. 1954–1955. pp.23. [300.]
ii. 1956. pp.32. [400.]
iii. 1957. pp.35. [350.]
iv. 1958. pp.40. [650.]
v. 1959. pp.50. [600.]

CIVIC centres. Public library of South Australia: Research service: [Adelaide] 1956. ff.4. [51.]*

COMMUNITY facilities. A list of selected references. National association of home builders of the United States: National housing center: Library: Bibliography series (no.1): [Washington 1956]. pp.[ii].140. [1070.]*
— Revised edition. . . . (no.4): [1959]. pp.[v]. 170. [1407.]*

COMMUNITY facilities. A list of selected references. National association of home builders: Community facilities committee: National hous-

ing center library: Bibliography series (no.1): [Washington] 1957. pp.[iii].140. [1070.]*

[DAVID C. ANDERSON *and others*], Planning references. Number one [–5]. October 1957 [–September 1958]. Local planning office: Library: [Sacramento] 1957–1958. pp.[240.]

CAROLINE SHILLABER, References on city and regional planning. Massachusetts institute of technology: Technology monographs: Library series (no.2): [Cambridge 1959]. pp.[vi].41. [500.]*

CENTRO interamericano de vivienda y planeamiento. Servicio de intercambio científico y documentación. Catálogo de publicaciones no.2. Unión panamericana: Departamento de asuntos económicos y sociales: Programa de vivienda, planeamiento y edificación: Bogotá 1959. pp. [iv].58. [500.]

A STUDENT's guide to resources for professional planning. University of Illinois: Department of city planning [&c.]: Urbana 1959. ff.[iv].36. [300.]*

W[ALDEMIRO] BAZZANELLA, Problemas de urbanização na América latina. Fontes bibliográficas. Centro latinoamericano de pesquisas em ciências

sociais: Publicação (no.2): Rio de Janeiro 1960.
pp.125. [547.]

JEAN VIET, Les villes nouvelles. Éléments d'une
bibliographie annotée. Unesco: Rapports et docu-
ments de sciences sociales (no.12): 1960. pp.84.
[865.]

— Supplement. Publications relating to urban
renewal. Public library: Washington, D.C.*

[i]. 1954–1955. pp.23. [300.]
ii. 1956. pp.32. [400.]
iii. 1957. pp.35. [350.]
iv. 1958. pp.40. [650.]
v. 1959. pp.50. [600.]

CIVIC centres. Public library of South Australia:
Research service: [Adelaide] 1956. ff.4. [51.]*

COMMUNITY facilities. A list of selected refer-
ences. National association of home builders of the
United States: National housing center: Library:
Bibliography series (no.1): [Washington 1956].
pp.[ii].140. [1070.]*

— Revised edition. . . . (no.4): [1959]. pp.[v].
170. [1407.]*

COMMUNITY facilities. A list of selected refer-
ences. National association of home builders:

Town Planning

Community facilities committee: National housing center library: Bibliography series (no.1): [Washington] 1957. pp.[iii].140. [1070.]*

[DAVID C. ANDERSON *and others*], Planning references. Number one [–5]. October 1957 [–September 1958]. Local planning office: Library: [Sacramento] 1957–1958. pp.[240.]

CAROLINE SHILLABER, References on city and regional planning. Massachusetts institute of technology: Technology monographs: Library series (no.2): [Cambridge 1959]. pp.[vi].41. [500.]*

CENTRO interamericano de vivienda y planeamiento. Servicio de intercambio científico y documentación. Catálogo de publicaciones no.2. Unión panamericana: Departamento de asuntos económicos y sociales: Programa de vivienda, planeamiento y edificación: Bogotá 1959. pp. [iv].58. [500.]

Ceramics.

1. *Periodicals*

LIST of periodicals on ceramics in the Science library. Science library: Bibliographical series (no.683): 1949. ff.3. [54.]*

PERIODICAL subscriptions and holdings, 1950–1951. New York state college of ceramics: Publication (no.5): Alfred, N.Y. 1951. ff.[i].14. [250.]

2. *General*

ABRIDGMENTS of the specifications relating to pottery. Patent office: 1863. pp.xi.180. [250.]
covers the period 1626–1861.
— 1862–1866. 1870. pp.vii.88. [100.]
no more published.

A LIST of works on pottery and porcelain in the National art library. South Kensington [*afterwards:* Victoria and Albert] museum: 1875. pp.24. [275.]
a copy in the Victoria and Albert museum library contains ms. additions by sir Augustus Wollaston Franks.

— Second edition. A list of books and pamphlets, in the National art library, on pottery and porcelain. 1885. pp.ix.148. [2250.]

CHAMPFLEURY [*pseud.* JULES FRANÇOIS FÉLIX HUSSON], Bibliographie céramique. Nomenclature analytique de toutes les publications faites en Europe et en orient sur les arts et l'industrie céramiques depuis le XVIᵉ siècle jusqu'à nos jours. 1881. pp.[v].xv.352. [3500.]

F[RIEDRICH] JAENNICKE, Die gesammte keramische literatur. Stuttgart 1882. pp.xvi.146. [1174.]

CERAMICS. South Kensington [*afterwards:* Victoria and Albert] museum: National art library Classed catalogue of printed books: 1895. pp.xi.354. [4000.]

JOHN CASPER BRANNER, Bibliography of clays and the ceramic arts. Geological survey: Bulletin (no.143): Washington 1896. pp.114. [3000.]
— — [second edition]. American ceramic society: Columbus, Ohio [printed] 1906. pp.451. [6027.]

READING list on arts and crafts. Ceramics. Grosvenor library: [Buffalo] 1900. pp.7. [125.]

JOHN HOMER HUDDILSTON, Lessons from greek pottery. To which is added a bibliography of greek ceramics. New York 1902. pp.xv.144. [750.]

LIST of works in the New York public library relating to ceramics and glass. [New York 1908]. pp.38. [ceramics: 900.]

[PETER JESSEN and PAUL FERDINAND SCHMIDT], Kunsttöpferei. Königliche museen zu Berlin: Hauptwerke der bibliothek des Kunstgewerbemuseums (no.7): Berlin 1908. pp.26. [200.]

ARBEIDER i ler, sten og glas. Kunstindustrimuseets og Kunst- og haandværksskolens bibliothek: Bøger for haandværkere (no.vii): Kristiania 1908. pp.25. [250.]
— Tillæg. 1909. pp.[4]. [14.]

M[ARC] L[OUIS] SOLON, Ceramic literature: an analytical index to the works published in all languages on the history and the technique of the ceramic art, also to the catalogues of public museums, private collections and of auction sales. 1910. pp.xix.660. [4000.]

Ceramics

SUBJECT list of works on the silicate industries (ceramics and glass). Patent office library: Subject lists (n.s. CD–CK): 1914. pp.iv.84. [ceramics: 350.]

SELECTED list of books on ceramics and glassware. Public library of New South Wales: Sydney 1919. pp.12. [200.]

LIST of references on pottery. Library of Congress: Washington 1921. ff.8. [118.]*
— [supplement]. 1938. ff.31. [261.]*
— — Selected list of references on the manufacture of pottery, 1939 to date. 1946. ff.4. [35.]

CERAMIC abstracts. American ceramic society [Urbana, Ill.; *afterwards:*] Menasha, Wis.; Easton, Pa.

 i. 1922. Ross C. Purdy, editor. pp.[ii].382. [2000.]
 ii. 1923. pp.[ii].321. [2000.]
 iii. 1924. pp.[ii].398. [2500.]
 iv. 1925. pp.[ii].419. [2500.]
 v. 1926. pp.[ii].493. [3000.]
 vi. 1927. pp.[ii].718. [4000.]
 vii. 1928. pp.[ii].1023. [6000.]
 viii. 1929. pp.[ii].1099. [6000.]
 ix. 1930. pp.[ii].1295. [7000.]
 x. 1931. pp.[ii].1047. [6000.]

xi. 1932. pp.[ii].797. [5000.]
xii. 1933. pp.[ii].575. [5000.]
xiii. 1934. pp.[ii].386. [5000.]
xiv. 1935. pp.[ii].369. [5000.]
xv. 1936. pp.[ii].429. [5000.]
xvi. 1937. pp.[ii].436. [5000.]
xvii. 1938. pp.[ii].449. [5000.]
xviii. 1939. pp.[ii].396. [5000.]
xix. 1940. pp.[ii].371. [4000.]
xx. 1941. pp.[ii].344. [3500.]
xxi. 1942. pp.[ii].310. [3500.]
xxii. 1943. pp.[ii].265. [3000.]
xxiii. 1944. pp.[ii].267. [3000.]
xxiv. 1945. pp.[ii].281. [3000.]

continued in the Society's Journal.

[A. SCOTT and — BRATTON], Catalogue of the ceramic library, Central school of science & technology [*afterwards:* North Staffordshire technical college], Stoke-on-Trent, including the Solon library, the Ceramic society library, and the library of the Pottery department of the School. Hanley [printed]. pp.iv.228. [5000.]

— Supplement. 1930. pp.[ii].95. [1500.]

ESSAI de bibliographie des arts et industries céramiques. Ouvrages de langue française. Institut de céramique française: 1932.

CERAMIC materials as dielectrics. Science library: Bibliographical series (no.140): 1934. ff.[i].5. [86.]*

PRESSURE-MOULDING of ceramics. Science library: Bibliographical series (no.191): 1935. ff.[i]. 3. [50.]*

WACŁAW WOLSKI-URBANKOWSKI, Bibliografia polskiej ceramiki szlachetnej. (Literatura polska i obca dotycząca Polski). Warszawa 1938. pp.[ii]. 65. [521.]

BIBLIOGRAPHY — pottery. Works progress administration: Division of women's and professional projects: W. P. A. technical series: Technical services laboratory circular (no.2): Washington 1939. ff.[ii].21.*

AURELIO MINGHETTI, Ceramisti. Enciclopedia biografia e bibliografica 'Italiana' (ser.xli): Milano 1939. pp.5–453. [6000.]

WALTER A[UGUST] STAEHELIN, Bibliographie der schweizerischen keramik vom mittelalter bis zur neuzeit. Basel [1947]. pp.39. [350.]

W. B. HONEY, Pottery and porcelain. National book league: Reader's guide: 1950. pp.20. [130.]

A LIST of the published writings of John Davidson Beazley. Oxford 1951. pp.27. [200.]
the writings are for the most part on greek vases.

J[OHN] H[ENRY] KOENIG and W[ILLIAM] H[ENRY] EARHART, Literature abstracts of ceramic glazes. [Revised edition]. Philadelphia 1951. pp.iv.395. [1500.]

JEAN GORELY, A selective bibliography of books and magazine articles on Wedgwood and other ceramics. A working list. Wellesley college: Library: 1953. ff.[i].6. [150.]*

ENAMELLING — porcelain, Public library of South Australia: Research service: [Adelaide] 1956. ff.7. [94.]*

JAN FLAJŠHANS [*and others*], Umělecká výroba keramická, sklářská a zlatnická v literatuře. Universita: Knihovna: Čteme a studujeme (1957, no.3): Praze [1957]. pp.[ii].88. [1500.]

LIBRARY catalogue. North Staffordshire technical college. Stoke-on-Trent [1960]. pp.227. [6500.]
— Supplement. 1960. pp.[19]. [250.]*

Painting.

CHRISTOPHE THÉOPHILE DE [CHRISTOPH GOTTLIEB VON] MURR, Bibliothèque de peinture, de sculpture, et de gravure. Francfort &c. 1770. pp.[xvi]. 406+407–778.[xxviii]. [4000.]

A LIST of works on painting in the National art library. South Kensington museum: 1881. pp. [iv].48. [850.]
— Second edition. 1883. pp.vii.157. [2500.]

J[AN] F[REDERIK] VAN SOMEREN, Essai d'une bibliographie de l'histoire spéciale de la peinture et de la gravure en Hollande et en Belgique [1500–1875]. Amsterdam, &c. 1882. pp.x.207.ix.[iii]. [2000.]
350 copies printed.

BERTHOLD HAENDCKE, Architektur, plastik und malerei. Centralkommission für schweizerische landeskunde: Bibliographie der schweizerischen landeskunde (section v 6 a–c): Bern 1892. pp.ix. 100. [painting: 750.]

[PETER JESSEN and JEAN LOUBIER], Dekorative

malerei. Königliche museen zu Berlin: Haupt-
werke der bibliothek des Kunstgewerbe-museums
(no.2): Berlin 1896. pp.iv.26. [250.]

—— Dritte auflage. [By P. Jessen and R.
Bernoulli]. 1908. pp.33. [300.]

FELIX BECKER, Schriftquellen zur geschichte der
altniederländischen malerei nach den haupt-
meistern chronologisch geordnet. 1. Kritik und
commentar der quellen. Leipzig 1897. pp.94. [50.]

HENRY TENNYSON FOLKARD, Painters and paint-
ing. A list of books. Free public library: Wigan
1904. pp.89. [1750.]
25 copies printed.

READING list of books in the Aberdeen public
library relating to reproductions of famous
pictures presented to the School board. School
board: Aberdeen [1912]. pp.24. [500.]
the books relate to the pictures themselves.

LIST of references on post-impressionists, futur-
ists, cubists, etc. Library of Congress: Washington
1913. ff.5. [63.]*

PAUL FIERENS, La peinture et les peintres. [Réper-
toires des ouvrages à consulter:] Bruxelles 1916.
pp.xi.124.[x]. [902.]

Painting

STANLEY LOTHROP, A bibliographical guide to Cavallini and the florentine painters before 1450. American academy: Rome 1917. pp.58. [260.]

MARY JOSEPHINE BOOTH, Index to material on picture study. Useful reference series (no.26): Boston 1921. pp.92. [1500.]

[KEPPEL ARCHIBALD CAMERON CRESWELL], A provisional bibliography of painting in muhammadan art. [1922]. pp.11. [200.]

ERIC RAYMOND MCCOLVIN, Painting: a guide to the best books with special reference to the requirements of public libraries. 1934. pp.3–216. [1500.]

[F. SCHMID], Exhibition of books on the practice of drawing and painting from 1650 to 1850. University of London: Courtauld institute of art: 1934. ff.[i].30. [100.]*

X-RAY examination of paintings. Science library: Bibliographical series (no.109): 1934. single sheet. [15.]*

H. VAN HALL and BERTHA WOLTERSON, Repertorium voor de geschiedenis der nederlandsche schilder- en graveerkunst sedert het begin der 12de eeuw tot het eind van 1932. Frederik Muller-fonds: 's-Gravenhage [1935–]1936. pp.xxviii.716. [18,269.]

— — 1933–1946. 1949. pp.xxii.397. [9034.]

THE HISTORY of painting. Library association: County libraries section: Readers' guide (no.26): 1939. pp.20. [350.]

A. I. SAVITSKAYA, Классики и ведущие мастера русской живописи. Рекомендательный указатель литературы. Государственная ордена Ленина библиотека [&c.]: Москва 1947. pp.48. [250.]

BARBARA JUNE CRAIG, Rock paintings and petroglyphs of south and central Africa. Bibliography of prehistoric art. University of Cape Town: School of librarianship: Bibliographical series: [Capetown] 1947. ff.[ii].v.58. [272.]*

— — 1947–1958. By Ingrid Rosenkranz. 1958. pp.[iii].iii.24. [231.]*

ISABEL STEVENSON MONRO and KATE M[ARGARET] MONRO, Index to reproductions of american paintings . . . in . . . books. New York 1948. pp.731. [825.]

RAYMOND LISTER, A title-list of books on miniature painting. Linton, Cambridge 1952. pp.3–18. [350.]
60 copies printed.

K[EPPEL] A[RCHIBALD] C[AMERON] CRESWELL, A

bibliography of painting in Islam. Institut français d'archéologie orientale: Art islamique (vol.i): Le Caire 1953. pp.100. [1000.]

ISABEL STEVENSON MONRO and KATE M[ARGARET] MONRO, Index to reproductions of european paintings. A guide to pictures in . . . books. New York 1956. pp.668. [10,000.]

MARY TOM OSBORNE, Advice-to-a-painter poems 1633–1856. An annotated finding list. University of Texas: [Austin] 1949. pp.[ii].92. [100.]

PAINTING for pleasure. Surrey county library: Book list (no.11): [Esher 1958]. pp.[iii].12. [75.]*

MONIQUE FEYAERTS, La peinture en Belgique des origines à nos jours. Bibliographie choisie et commentée d'ouvrages en langue française à l'usage de la bibliothèque du second degré. Commission belge de bibliographie: Bibliographia belgica (no.47): Bruxelles 1960. pp.[vi].462. [606.]*

Posters.

CATALOGUE of an exhibition of illustrated bill-posters. Grolier club: New York 1890. pp.12. [100.]

H. GROSCH, Katalog over Museets bibliothek og dets samling af mønsterblade. Kunstindustri-museet: Kristiania 1891. pp.xvi.80. [1600.]

SOME modern posters shown at Quincy, Massa-chusetts in aid of the Quincy city hospital. Boston [printed] 1895. pp.16. [218.]

A DESCRIPTIVE catalogue of posters, chiefly american, in the collection of Charles Knowles Bolton, with biographical notes and a biblio-graphy. Brookline, Mass. 1895. pp.[16]. [125.]

J. J. KAIWAL, Bibliographie der deutschen reklame-, plakat-, und zeitungs-literatur. Kaindls reklame-bücherei (vol.i): Wien 1918. pp.xiv.132. [3500.]

POSTER catalog. War production board: Wash-ington [1942]. pp.[16].

Posters

[RENÉ GANDILHON], Inventaire des affiches de la guerre de 1939–1945 conservés aux Archives de la Marne. Châlons-sur-Marne 1949. pp.53. [344.]

[MONA BACHKE and TORA BØHN], Moderne plakater, danske og britiske. Utstilling. Nordenfjeldske kunstindustrimuseum: [Trondhjem 1953]. pp.[ii].18. [80.]

INVENTAIRE des affiches conservées aux archives de la Marne. Arcis-sur-Aube 1953–1957. pp.xiv. 436+vii.591. [17,417.]

WOLFGANG KOHTE, Fünfzig jahre deutsche geschichte 1907–1957 in plakaten und flugblättern. Ausstellung im Deutschherrenhaus. [Coblenz 1957]. pp.32. [43.]

PIROSKA MUNKÁCSI, A Magyar Tanácsköztarsaság plakátjai az Országos Sczéchényi könyvtárban. Budapest 1959. pp.260. [716.]*

B[ORIS] S[TEPANOVICH] BUTNIK-SIVERSKY, Советский плакат эпохи гражданской войны 1918–1921. Москва 1960. pp.583. [3694.]

SVENSK reklam konst. Kungl. bibliotek: Utställningskatalog (no.28): [Stockholm 1960]. pp. 24. [129.]

Posters

PAUL WEMBER [and JOHANNES CLADDERS], Die
jugend der plakate 1887–1917. Kaiser Wilhelm
museum: Krefeld [1961]. pp.28.342. [863.]
 a catalogue of the museum.

Cinematography.

1. *Periodicals*

RÉPERTOIRE mondial des périodiques cinémato-
graphiques. Cinémathèque de Belgique: Biblio-
graphie internationale du cinéma: Bruxelles 1955.
pp.iii–xii.131. [644.]
— 2ᵉ édition. 1960. pp.[148]. [769.]

CINÉMA, revues et répertoires. Ministère de
l'éducation nationale: Direction générale de la
eunesse et des sports: Fiches documentaires:
[1958]. pp.12. [45.]

2. *General*

LIST of recent references on the moving picture
industry. Library of Congress: Washington 1917.
ff.4. [51.]*
— [another edition]. 1922. ff.27. [363.]*
— — [supplement]. Moving picture industry.

Compiled by Florence S[elma] Hellman. 1927. pp.31. [380.]*

MOTION pictures. Russell Sage foundation: Library: Bulletin (no.54): New York 1922. pp.4. [75.]

CATALOGUE of books and publications on cinematography and allied subjects. British empire film institute: British film library: 1928. pp.16. [250.]

— [another edition]. Library catalogue. British film institute: 1948. pp.68. [1250.]

CATALOGUE of copyright entries. Part I, group 3. Dramatic compositions and motion pictures. Library of Congress: Copyright office: Washington.

 i. 1928. pp.iii.527. [cinematography: 2236.]
 ii. 1929. pp.iii.572. [2335.]
 iii. 1930. pp.iii.642. [2052.]
 iv. 1931. pp.iii.601. [1670.]
 v. 1932. pp.iii.555. [1544.]
 vi. 1933. pp.iii.535. [1607.]
 vii. 1934. pp.iii.567. [1555.]
 viii. 1935. pp.iii.575. [1698.]
 ix. 1936. pp.iii.595. [1729.]
 x. 1937. pp.iii.622. [1878.]

xi. 1938. pp.iii.487. [1768.]

xii. 1939. pp.iii.328. [1638.]

xiii. 1940. pp.iii.299. [1684.]

xiv. 1941. pp.iii.299. [2027.]

xv. 1942. pp.iii.235. [2056.]

xvi. 1943. pp.[iii].205. [1811.]

xvii. 1944. pp.[iii].230. [1820.]

xviii. 1945. pp.[iii].263. [1802.]

xix. 1946. pp.[iii].387. [2153.]

[*continued as:*]

Catalogue of copyright entries. Third serie s.
Parts 12-13. Motion pictures and filmstrips.

i. 1947. pp.iv.44+iv.45-83. [1809.]

ii. 1948. pp.v.52+v.53-96. [1703.]

iii. 1949. pp.vi.62+vii.63-127. [2012.]

iv. 1950. pp.viii.80+viii.81-152. [2530.]

v. 1951. pp.viii.78+viii.79-153. [2818.]

vi. 1952. pp.viii.86+v.87-167. [2126.]

vii. 1953. pp.viii.90+viii.91-145. [2185.]*

viii. 1954. pp.viii.68+viii.69-136. [2775.]*

ix. 1955. pp.ix.72+73-144. [2834.]

x. 1956. pp.ix.74+ix.145. [2971.]*

xi. 1957. pp.viii.72+viii.73-133. [3410.]

xii. 1958. pp.viii.73+viii.75-140. [3711.]*

xiii. 1959. pp.viii.56+viii.57-109. [3916.]*

xiv. 1960. pp.viii.61+viii.62-127. [4488.]*

xv. 1961. pp.viii.83+viii.84-134. [4988.]*

xvi. 1962. pp.ix.58+ix.59–117. [4090.]*
*in progress; the issues for 1920–1927 formed part
of the main text of part 1 of the* Catalogue, *and those
or earlier years of part 3.*

CHECK-LIST of material in Academy library.
Academy of motion picture arts and sciences:
[Hollywood 1936]. ff.35. [400.]*

CINEMATOGRAPHY. A selected list of books com-
piled by the British film institute. Second edition.
National book council; Book list (no.141): 1936.
pp.[4]. [150.]

ANNE L[AURA] BADEN, Moving pictures in the
United States and foreign countries. A selected
list of recent writings. Compiled . . . under the
direction of Florence S[elma] Hellman. Library of
Congress: [Washington] 1936. pp.72. [856.]*
— [supplement]. 1940. pp.67. [573.]*

THE CINEMA. Public libraries: Bristol [1938].
pp.20. [300.]

FRANCES [MARY] CHRISTESON, A guide to the
literature of the motion picture. University of
Southern California: Cinematography series
(no.1): [Los Angeles] 1938. pp.79. [120.]

A LIST of books on cinematography. British

film institute. 1938. pp.12. [225.]
— Second edition. 1938. pp.12. [225.]

HANS TRAUB and HANNS WILHELM LAVIES, Das deutsche filmschrifttum. Eine bibliographie der bücher und zeitschriften über das filmwesen. Leipzig 1940. pp.iv.247. [3129.]

THE FILM INDEX. A bibliography. Vol.1. The film as art. Compiled by workers of the writers' program of the Work projects administration in the city of New York. [Edited by Harold Leonard]. New York 1941. pp.xxxvi.723. [12,500.]
no more published.

THE BRITISH film institute book list, being a list of books of special interest available . . . in the library of the Institute. British film institute: Leaflet (no.41): [1944]. pp.12. [250.]

ANNUAL communications bibliography: motion pictures—radio—music. . . . Supplement to volume one, Hollywood quarterly. Berkeley &c. 1946. pp.[v].59. [1250.]
no more published.

[IRIS BARRY, HELEN FIELD CONOVER and HELEN FITZ-RICHARD], The motion picture. A selected booklist. American library association: [Chicago 1946]. pp.[20]. [66.]

ROGER MANVELL, Film. National book league: Reader's guide: 1947. pp.12. [50.]
the bibliography proper is by William Arthur Munford.

LIST of selected books on the film. Corporation public libraries: Glasgow 1948. pp.12. [150.]

CARL VINCENT, RICARDO REDI and FRANCO VENTURINI, Bibliografia generale del cinema. Collana di studi cinematografici di bianco e nero: Roma 1953. pp.253. [5000.]

CATALOGUE. Section cinéma. Institut des hautes études cinématographiques: Bibliothèque: [1953]. ff.[iii].iii.251. [2500.]*

VIRGINIA M. BEARD, The film reference shelf. A selected list. American library association: Chicago 1953. pp.6.

[] ALVES COSTA, Breve história da imprensa cinematográfica portuguesa. Cine-club de Porto: [Oporto] 1954. pp.47. [50.]

M[ARIO] R[ODRÍGUEZ] ARAGÓN, Bibliografía cinematográfica española. Dirección general de archivos y bibliotecas: Madrid 1956. pp.343. [425.]

O[LGA] N[IKOLAEVNA] LEVSHINA, Новое в технике кино ... Рекомендательный обзор

литературы. Государственная... библиотека СССР имени В. И. Ленина: Центральная политехническая библиотека: Новости техники (no.11): Москва 1957. pp.21. [15.]

FOTOGRAFI og filmteknik. Centralbibliotek: [Odense 1958]. pp.10. [150.]

BØGER om film. Fortegnelse over bøgerne i det Danske filmmuseums bibliotek. [Copenhagen] 1961. pp.190. [2500.]

F[RIEDA] ADRIAN, Presse, film und rundfunk im spiegel der periodischen literatur. Westfällisch-niederrheinisches institut für zeitungsforschung: Dortmund 1960. pp.115. [1500.]

M[ARINA] E[VGENEVNA] ZELENINA, Искусство́ кино. Государственная ... библиотека СССР им. В. И. Ленина: В помощь слушателям университетов культуры: Рекомендательный указатель (no.7): Москва 1961. pp.52. [250.]

кино. Государственная публичная библиотека имени М. Е. Салтыкова-Щедрина: [Leningrad 1961]. pp.16. [60.]

YU. RUBINSHTEIN, Книги о кино (1917–1960). Аннотированная библиография. Институт истории искусств: Москва 1962. pp.183. [1348.]

3. *Filmed books and plays*

CATALOGUE of the stories and plays owned by Fox film corporation. Los Angeles [1931]. pp.222. [820.]

— [another edition]. 1935. pp.326. [1225.]

A. G. S. ENSER, Filmed books and plays. A list of books and plays from which films have been made, 1918–1949. 1950. pp.xiv.218. [1250.]

ISOLDE DIETRICH, Das buch als film. Ein verzeichnis von büchern, die verfilmt wurden. Stadtbücherei: Wolfsburg 1959. pp.64. [250.]

4. *Miscellaneous*

LIST of references on writing of scenarios for moving pictures. Library of Congress: Washington 1919. ff.3. [34.]*

CLIVE M. KOON and MARTHA R. MCCABE, Good references on visual aids in education: motion pictures. Office of education: Bibliography (no. 32): Washington 1935. pp.[ii].10. [50.]

ELAINE M. DEAR, LOUISE S. KJELLSTROM and JENNY E. TURNBULL, Motion pictures in sports. A bibliography and film list. American association for health, physical education and recreation: [Washington 1939]. pp.34. [250.]

SELECTED bibliography of volumes relating to the creative aspects of motion picture production. Bureau of aeronautics: Photographic science laboratory [Anacostia]: [Washington *c*.1945]. pp. [23]. [300.]*

HOW movies are produced and distributed. Library of Congress: Washington 1946. ff.5. [21.]*

THE BRITISH film industry. House of commons: Library: Bibliography (no.40): [1947]. ff.5. [35.]*

MOVING picture studios. Public library of South Australia: Research service: [Adelaide] 1956. ff.8. [120.]*

B[ORIS] V[AHSILEVICH] KUBEEV, Научная кинодокументация, выполненная в вузах МВО СССР в 1948–1957 гг. Сборник научно-исследовательских работ. Москва 1958. pp.103. [200.]

THE INFLUENCE of the cinema on children and adolescents. An annotated international bibliography. Unesco: Department of mass communications: Reports and papers on mass communication (no.31): [Paris 1961]. pp.105. [491.]

Special Subjects

Adobe.

LIST of references on pisé de terre and adobe construction. Library of Congress: Washington 1931. ff.6. [68.]*

Aesthetics. [*see also* **Art**].

CHARLES MILLS GAYLEY and FRED NEWTON SCOTT, A guide to the literature of æsthetics. University of California: Library bulletin (no.11): Berkeley 1890. pp.116. [1750.]

SELECT list of references on æsthetics. Library of Congress: Washington [*c.*1910]. ff.4. [18.]*

ERNST BRAGMANN, Geschichte des ästhetik und kunstphilosophie. Ein forschungsbericht. Leipzig 1914. pp.40. [250.]

T. M. MUSTOXIDI, Bibliographie générale de l'esthétique française des origines à 1914. 1920. pp.lxiv. [1400.]
published as a supplement to the author's Histoire de l'esthétique française.

BRIEF list of references on the place of beauty in

Special Subjects

civic life. Library of Congress: Washington 1921.
ff.3. [36.]*

JOHN WILLIAM DRAPER, Eighteenth century
english aesthetics: a bibliography. Anglistische
forschungen (no.71): Heidelberg 1931. pp.140.
[1300.]

WILLIAM A[LEXANDER] HAMMOND, A biblio-
graphy of æsthetics and of the philosophy of the
fine arts from 1900 to 1932. New York [1933].
pp.viii.183. [2191.]
——Revised...edition. 1934. pp.x.205. [2191.]

ALBERT R[ICHARD] CHANDLER, A bibliography
of experimental aesthetics. Ohio state university
studies (= Bureau of education: Research mimeo-
graphs, no.1): Columbus 1933. pp.iii.25. [801.]*

GEORGE N. BELKNAP, A guide to reading in
aesthetics and theory of poetry. University of
Oregon: Publication (vol.iv, no.9 = Studies in
college teaching, Bulletin 5): Eugene, Oregon
1934. pp.91. [aesthetics: 100.]

ALBERT R. CHANDLER and EDWARD N. BARNHART,
A bibliography of psychological and experimental
aesthetics, 1864–1937. Berkeley, Cal. 1938. ff.[ii].
190. [1739.]*

NORBERTO PINILLA, Bibliografía de estética. Santiago de Chile 1939. pp.64. [500.]

ETHEL M. ALBERT [*and others*], A selected bibliography on values, ethics, and esthetics in the behavorial sciences and philosophy, 1920–1958. Glencoe, Ill. [1959]. pp.xviii.342. [2006.]*

Z[ORY GRANTOVICH] APRESYAN, Эстетика. Библиография 1956–1960. Москва 1963. pp.263. [2500.]

Akademiya arkhitekturui SSSR.

[R. V. GALINSKY], Каталог, книги, журналы. Москва 1936. pp.712. [50.]

Alciati, Andrea.

HENRY GREEN, Andrea Alciati and his book of emblems. A biographical and bibliographical study. 1872. pp.xvi.344. [179.]

GEORGES [GRATET-] DUPLESSIS, Les emblèmes d'Alciat. Bibliothèque internationale de l'art: Les livres à gravures du XVIᵉ siècle: 1884. pp.[iii]. 64. [126.]

A COLLECTION of the emblem books of Andrea Alciati . . . in the library of George Edward Sears. New York 1888. pp.40. [34.]
100 copies privately printed.

Arai, Alberta A.

BIBLIOGRAFÍA del arquitecto Alberto T. Arai. Feria mexicana del libro: México 1956. ff.[i].15. [114.]*

Ardennes.

[JEAN BAPTISTE JOSEPH] BOULLIOT, Biographie ardennaise, ou histoire des Ardennais qui se sont fait remarquer par leurs écrits. 1830. pp.xvi.496+ 524. [2500.]

INVENTAIRE sommaire des archives départementales. . . . Ardennes. Charleville. [very large number.]

 i. Séries A–B. Par Ed[mond] Sénemaud et [Jean] Paul Laurent. Charleville 1890. pp.vii.406.

 ii. [*not yet published*].

 iii. Séries C–F. Par P. Laurent [and A. Semer]. 1905–1919. pp.xi.612+472+160.

 iv. Séries G–I. Par E. Sénemaud [and] P. Laurent. 1888. pp.viii.200.

 v. Série H, supplément. Par P. Laurent. 1901. pp.viii.193.

 vi–vii. Série E, supplément. 1902–1923. pp.viii.332+iv.52.

in progress.

[CHARLES] HENRI JADART, Essai d'une biblio-
graphie historique et archéologique du départe-
ment des Ardennes. Arcis-sur-Aube 1898. pp.28.
[200.]

50 copies printed.

BIBLIOGRAPHIE rémoise et ardennaise. Liste des
publications de Charles-Henri Jadart. Reims 1900.
pp.15. [150.]

100 copies printed.

—— [another edition]. 1922. pp.[ii].54. [445.]

[PAUL COLLINET and JULES LETELLIER], Inventaire
sommaire de la collection de notes et documents
sur l'histoire des Ardennes, réunis par le m^is Olivier
de Gourjault et déposés à la Bibliothèque. Sedan
1903. pp.71. [1650.]

[CHARLES] HENRI JADART, Les édifices religieux
du département des Ardennes. Essai de statistique
et de bibliographie. Reims 1906. pp.38. [25.]

[CHARLES] HENRI JADART, Bibliographie des
églises ardennaises. Dôle [printed] 1908. pp.30.
[25.]

25 copies printed.

Arlington amphitheatre.

LIST of references on the Arlington memorial

amphitheater. Library of Congress: Washington 1922. ff.2. [17.]*

Arlon.

CH[ARLES] DUBOIS, Orolaunum. Bibliographie et documents. Institut archéologique de Luxembourg: Annales (vol.lxxvii): Arlon 1946. pp.70. [500.]

Armour and weapons.

A LIST of books and photographs in the National art library illustrating armour and weapons. South Kensington museum [*afterwards:* Victoria and Albert museum]: 1883. pp.68. [1000.]

ENZIO MALATESTA, Armi ed armaioli. Enciclopedia biografica e bibliografica 'italiana' (ser.l): Milano 1939. pp.5-437. [7500.]

G[IUSEPPE] MORAZZONI, Saggio bibliografico delle armi antiche italiane. Associazione amatori armi antiche: Milano 1949. pp.73. [300.]

K[EPPEL] A[RCHIBALD] C[AMERON] CRESWELL, A bibliography of arms and armour in Islam. Royal asiatic society: James G. Forlong fund (vol.xxv): 1956. pp.79. [497.]

[KENNETH G. WYNN], Arms and armour. The Connoisseur 1901–1960. 1960. pp.44. [325.]

Art galleries.

LIST of fine art galleries in the United States. Library of Congress: Washington 1921. ff.3. [44.]*

ART galleries and museums — architecture. Public library of South Australia: Research service: [Adelaide] 1958. ff.7. [118.]*

Auditorium.

LIST of references on municipal auditoriums. Library of Congress: [Washington] 1926. ff.6. [53.]*

Avebury.

W[ILLIAM] JEROME HARRISON, Great stone monuments of Wiltshire. A bibliography of Stonehenge and Avebury. Devizes [1901]. pp.169. [1750.]

Beardsley, Aubrey.

A[LBERT] E[UGENE] GALLATIN, Aubrey Beardsley. Catalogue of drawings and bibliography. Grolier club: New York 1945. pp.[vii].141.[xx]. [200.]
300 copies printed.

A. E. GALLATIN and ALEXANDER D. WAINWRIGHT, The Gallatin Beardsley collection in the Princeton university library. A catalogue. Princeton 1952. pp.43. [400.]

Berenson, Bernhard.

WILLIAM MOSTYN-OWEN, Bibliografia di Bernard Berenson. Milano 1955. ff.76. [500.]
printed on one side of the leaf.

Bewick, John and Thomas.

[E. J. SELWYN], A descriptive and critical catalogue of works illustrated by Thomas and John Bewick. 1851. pp.viii.77.8. [91.]

THOMAS HUGO, The Bewick collector. A descriptive catalogue of the works of Thomas and John Bewick. . . . By . . . the possessor of the collection. 1866. pp.xxiv.562. [1000.]
— — A supplement. 1868. pp.xxxii.353. [500.]

BASIL ANDERTON and W[ILLIAM] H. GIBSON, Catalogue of the Bewick collection ([John William] Pease bequest). Public libraries committee: Newcastle-upon-Tyne [1904]. pp.[iii].111. [331.]

S[YDNEY] ROSCOE, Thomas Bewick. A biblio-

graphie raisonné of editions of the General history of quadrupeds, the History of british birds and the Fables of Aesop issued in his life-time. 1953. pp.xxx.198. [50.]

Blake, William.

CATALOGUE of books, engravings, water-colors & sketches by William Blake exhibited at the Grolier club. New York 1905. pp.xix.147. [89.]

WILLIAM BLAKE. An exhibition. Grolier club: New York 1919. pp.vii.12. [40.]

[SIR] GEOFFREY [LANGDON] KEYNES, A bibliography of William Blake. Grolier club: New York 1921. pp.xvi.517. [775.]
250 copies printed.
— — [another edition of one section]. William Blake's illuminated books. A census compiled by G. Keynes and Edwin Wolf 2nd. Grolier club: New York 1953. pp.xviii.124. [200.]

[ELIZABETH MONGAN and EDWIN WOLF], William Blake, 1757–1827. A descriptive catalogue of an exhibition . . . selected from collections in the United States. Museum of art: Philadelphia 1939. pp.xxi.175. [283.]

KATHLEEN RAINE, William Blake. British coun-

cil: British book news: Bibliographical series of supplements: 1950. pp.40. [100.]

KERRISON PRESTON, William Blake 1757–1827. Notes for a catalogue of the Blake library at the Georgian house, Merstham. Cambridge 1960 [1961]. pp.47. [500.]
— — Second edition. 1962. pp.48. [500.]

GERALD EADES BENTLEY and MARTIN K. NURMI, A Blake bibliography. Annotated lists of works, studies, and Blakeana. Minneapolis [1964]. pp. xix.393.

Bock, Franz.

[FRANZ BOCK], Verzeichniss der schriften über mittelalterliche kunst veröffentlicht . . . von . . . Fr. Bock. Köln &c. 1872. pp.24. [80.]

Bronze.

LIST of references on bronze art workers. Library of Congress: Washington 1915. ff.3. [34.]*

Cantonments.

LIST of references on cantonment buildings, their construction, equipment, sanitation and care. Library of Congress: Washington 1918. ff.6. [87.]*

Capitol, Washington.

THE UNITED STATES Capitol: a selected list of references. Library of Congress: Washington 1949. ff.34. [176.]*

Carpets.

LIST of references on oriental rugs. Library of Congress: Washington 1918. ff.3. [41.]*

Castles.

LIST of references on german castles. Library of Congress: Washington 1916. ff.2. [22.]*

Cathedrals.

JOHN HARVEY, English cathedrals. National book league: Readers' guide: 1951. pp.28. [150.]

Cavallini, Pietro.

STANLEY LOTHROP, A bibliographical guide to Cavallini and the florentine painters before 1450. American academy: Rome 1917. pp.58. [Cavallini: 13.]

Cézanne, Paul.

GABRIELLA UNTERSTEINER, "L'oeuvre" di Émile Zola e i suoi rapporti con Cézanne. Indicazioni

bibliografiche. Università degli studi di Milano: Corso di letteratura francese: Milano [1957]. pp. [ii].46. [400.]*

Charente.

G[USTAVE] CHAUVET, Statistique et bibliographie des sépultures pré-romaines du département de la Charente. 1900. pp.56. [35.]

Cheshire, Chester.

ERNEST AXON, Bibliography of Lancashire and Cheshire antiquities, 1890. [Manchester] 1891. pp. 12. [150.]

JOHN HIBBERT SWAN, Bibliography of Lancashire & Cheshire antiquities and biography. Manchester.
1893–1894. pp.22. [250.]
1895. pp.15. [200.]
1896. pp.16. [200.]
1898. pp.15. [200.]
1899. pp.11. [150.]

Chodowiecki, Daniel.

ARTHUR RÜMANN, Daniel Chodowiecki. Das werk: das graphische werk (vol.ii): Berlin [1926]. pp.87. [314.]

Choffard, Pierre Philippe.

VERA SALOMONS, Choffard. XVIIIth century french book-illustrators: 1912. pp.[viii].112.[xlvii]. [125.]

50 copies printed.

Church architecture.

CHURCH architecture. Public library of South Australia: Research service: [Adelaide] 1956. ff.9. [168.]★

Clay.

JOHN CASPER BRANNER, Bibliography of clays and the ceramic arts. Geological survey: Bulletin (no.143): Washington 1896. pp.114. [3000.]

—— [second edition]. American ceramic society: Columbus, Ohio [printed] 1906. pp.451. [6027.]

Communion tokens

W[ILLIAM] W. WOODSIDE, Communion tokens —a bibliography. [Carnegie museum: Pittsburgh 1958]. pp.26. [55.]★

Correggio, Antonio Allegri da.

IL CORREGGIO nei libri. Parma 1894. pp.[v].60. [250.]

SILVIA DE VITO BATTAGLIA, Correggio. Bibliografia. Reale istituto di archeologia e storia dell'arte: Bibliografie e cataloghi (vol.iii): Roma 1934. pp.x.354. [1161.]

Crane, Walter.

GERTRUDE C. E. MASSÉ, A bibliography of first editions of books illustrated by Walter Crane. 1923. pp.60. [125.]

Cranach, Lucas.

CAMPBELL DODGSON, Lucas Cranach. Société des études critiques: Bibliothèque de bibliographies critiques (no.8): [1900]. pp.17. [150.]

Cruikshank, George, Isaac, and Robert.

FREDERICK MARCHMONT, The three Cruikshanks. A bibliographical catalogue, describing . . . works . . . illustrated by Isaac, George & Robert Cruikshank. 1897. pp.[viii].128.xvii. [524.]
500 copies printed.

R[ICHARD] J[OHN] H[ARDY] DOUGLAS, The works of George Cruikshank. 1903. pp.ix.302. [631.]

ALBERT M. COHN, A bibliographical catalogue of the printed works illustrated by George Cruikshank. 1914. pp.226. [820.]

A[BRAHAM] S. W[OLF] ROSENBACH, A catalogue of the works illustrated by George Cruikshank and Isaac and Robert Cruikshank in the library of Harry Elkins Widener. Philadelphia 1918. pp. [x].279. [600.]

privately printed; the collection now forms part of Harvard university library.

ALBERT M. COHN, George Cruikshank. A catalogue raisonné of the works executed during the years 1806–1877. 1924. pp.xvi.376. [863.]

500 copies printed.

Dance of death.

[ÉTIENNE] GABRIEL PEIGNOT, Recherches historiques et littéraires sur les Danses des morts et sur l'origine des cartes à jouer. Dijon 1826. pp.lx.368. [100.]

H[ANS] F[ERDINAND] MASSMANN, Literatur der Todtentänze. Leipzig 1840. pp.136. [500.]

a supplement by Massmann appears in Serapeum (*Leipzig 1842*), iii.328–330.

[G. E. SEARS], A collection of works illustrative of the Dance of death . . . in the library of George Edward Sears. New York 1889. pp.42. [90.]

100 copies privately printed.

WILLIAM GEMMELL, Gemmell collection on the

Dance of death. Chronological list. [University of Glasgow: Glasgow] 1919. ff.[iv].iii.24.[iii]. [76.]*

DOODENDANS. Catalogus der verzameling Reichelt, de nederlandsche doodendans verzameling Schultz Jacobi. Universiteit. Bibliotheek: Amsterdam 1923. pp.54.

Delacroix, Eugène.

MAURICE TOURNEUX, Eugène Delacroix devant ses contemporains: ses écrits, ses biographies, ses critiques. Bibliothèque internationale de l'art: 1886. pp.iii–xxviii.181. [1000.]

Donatello.

[GAETANO MILANESI], Catalogo delle opere di Donatello e bibliografia degli autori che ne hanno scritto. Firenze 1887. pp.[iii].66. [150.]

Drawing.

KATALOG von werken über den zeichenunterricht. Neuwied 1876. pp.xxv.136. [1250.]
— Supplement. 1876. pp.xii.37. [350.]

A LIST of books and pamphlets in the National art library . . . on drawing, geometry, and perspective. South Kensington museum [*now* Victoria and Albert museum]: 1888. pp.92. [1000.]

AIDS in drawing and design for teachers and students. City library association: Springfield, Mass. 1914. pp.26. [400.]

[F. SCHMID], Exhibition of books on the practice of drawing and painting from 1650 to 1850. University of London: Courtauld institute of art: 1934. ff.[i].30. [100.]*

PAINTING and drawings. A selection of illustrated monographs on artists. Revised edition. Victoria and Albert museum library: [1939]. ff.[i].41. [500.]*

CARL WILLIAM DREPPERD, American drawing books. A contribution towards a bibliography. Public library: New York 1946. pp.20. [50.]

Dürer, Albrecht.

HANS WOLFGANG SINGER, Versuch einer Dürer bibliographie. Studien zur deutschen kunstgeschichte (no.41): Strassburg 1903. pp.xvi.98. [1307.]

— — Zweite . . . auflage. 1928. pp.xi.198. [2853.]

DÜRER-LITERATUR in Ungarn, 1800–1928. Kgl. Ungarisches ministerium für kultus und unterricht: Budapest 1928. pp.48. [179.]

HANNS BOHATTA, Versuch einer bibliographie der kunsttheoretischen werke Albrecht Dürers. Wien 1928. pp.[ii].33. [50.]

ALBRECHT DÜRER, 1528–1928. Egyszersmind kisérlet egy magyar Dürer-bibliografiához. Fővárosi nyilvános könyvtár: Aktuális kérdések irodalma (no.42): Budapest 1928. pp.36. [200.]

Eisen, Charles.

VERA SALOMONS, Charles Eisen. XVIIIth century french book-illustrators: 1914 [*sic*, 1921]. pp.197. [200.]

Emblems

[GEORGE SPENCER, MARQUIS OF BLANDFORD, *afterwards* DUKE OF MARLBOROUGH], Symbola et emblemata. 1808. pp.[ii].12. [225.]

[SIR WILLIAM STIRLING-MAXWELL], An essay towards a collection of books relating to proverbs, emblems, apophthegms, epitaphs and ana. Being a catalogue of those at Keir. 1860. pp.vii.244. [emblems: 250.]

75 copies privately printed.

HENRY GREEN, Andrea Alciati and his book of emblems. A biographical and bibliographical study. 1872. pp.xvi.344. [179.]

GEORGES [GRATET-] DUPLESSIS, Les emblèmes d'Alciat. Bibliothèque internationale de l'art: Les livres à gravures du XVIᵉ siècle: 1884. pp.[iii].64. [126.]

A COLLECTION of the emblem books of Andrea Alciati . . . in the library of George Edward Sears. New York 1888. pp.40. [34.]
100 copies privately printed.

A[NNE] G[ERARD] C[HRISTIAAN] DE VRIES, De nederlandsche emblemata. Geschiedenis en bibliographie tot de 18ᵈᵉ eeuw. Amsterdam 1899. pp. 91.clii. [246.]

[CAROLYN SHIPMAN], Catalogue of books of emblems in the library of Robert Hoe. New York 1908. pp.[ix].133. [450.]
100 copies privately printed.

MARIO PRAZ, Studies in seventeenth-century imagery. Volume two. A bibliography of emblem books. University of London: Warburg institute: Studies (vol.3): 1947. pp.iii–xi.210. [1200.]

JOHN LANDWEHR, Dutch emblem books. A bibliography. Biblioteca emblematica (vol.i): Utrecht [1962]. pp.xii.99. [261.]

Enamels.

[ALPHONSE] J[EAN] J[OSEPH] MARQUET DE VASSELOT, Bibliographie de l'orfèvrerie et de l'émaillerie en France. Société française de bibliographie: 1925. pp.xii.294. [2750.]

Engraving.

CHRISTOPHE THÉOPHILE DE [CHRISTOPH GOTT-LIEB VON] MURR, Bibliothèque de peinture, de sculpture, et de gravure. Francfort &c. 1770. pp. [xvi].406+407-778.[xxviii]. [4000.]

CHRISTOPHE THÉOPHILE DE [CHRISTOPH GOTT-LIEB VON] MURR, Bibliothèque glyptographique. Dresde 1804. pp.296. [1000.]

CATALOGUE of the books on bibliography, typography and engraving, in the New-York state library. Albany 1858. pp.3-143. [1250.]

GEORGES [GRATET-] DUPLESSIS, Essai de biblio-graphie, contenant l'indication des ouvrages relatifs à l'histoire de la gravure et des graveurs. 1862. pp.48. [656.]

AMBROISE FIRMIN-DIDOT, Essai typographique et bibliographique sur l'histoire de la gravure sur bois. 1863. coll.xviii.5-316. [500.]

J[AN] F[REDERIK] VAN SOMEREN, Essai d'une bibliographie de l'histoire spéciale de la peinture et de la gravure en Hollande et en Belgique [1500–1875]. Amsterdam &c. 1882. pp.x.207.ix.[iii]. [2000.]

350 copies printed.

HOWARD C[OPPUCK] LEVIS, A bibliography of american books relating to prints and the art and history of engraving. 1910. pp.ix.80. [500.]

150 copies printed.

GUSTAVE BOURCARD, Graveurs et gravures, France et étranger. Essai de bibliographie, 1540–1910. 1910. pp.iii–xvi.321. [400.]

400 copies printed.

HOWARD C[OPPUCK] LEVIS, A descriptive bibliography of the most important books in the english language relating to the art & history of engraving and the collecting of prints. 1912–1913. pp.xix. 572+142. [3000.]

350 copies printed; the author's copy, containing extensive notes and additions, is in the library of Congress.

FRANK WEITENKAMPF, Prints and their production. A list of works in the New York public

library. New York 1916. pp.iii.162. [2750.]

— — Supplement. 1917. pp.8. [100.]

PAUL COLIN, La gravure et les graveurs. [Répertoires des ouvrages à consulter:] Bruxelles 1916. pp.ix.93.[vi]. [610.]

— — [second edition]. pp.viii.344.xi. [2659.]

FRANÇOIS COURBOIN and MARCEL ROUX, La gravure française. Essai de bibliographie. 1927–1928. pp.435+551+[iv].201. [12,500.]

H. VAN HALL and BERTHA WOLTERSON, Repertorium voor de geschiedenis der nederlandsche schilder- en graveerkunst sedert het begin der 12de eeuw tot het eind van 1932. Frederik Muller-fonds: 's-Gravenhage [1935–]1936. pp.xxviii.716. [18,269.]

JOAN HASSALL, Wood engraving. National book league: Reader's guide: 1949. pp.16. [125.]

Expressionism.

PAUL RAABE [*and others*], Expressionismus. Literatur und kunst, 1910–1923. Eine ausstellung des deutschen literaturarchivs im Schiller-natio-nalmuseum. Schiller-nationalmuseum: Sonder-ausstellungen: Katalog (no.7): Stuttgart [1960]. pp.358. [1000.]

Fraser, Claud Lovat.

[CHRISTOPHER MILLARD], The printed work of Claud Lovat Fraser. 1923. pp.iii–xii.107. [743.]
275 copies printed.

Furniture.

A LIST of works on furniture in the National art library, South Kensington museum. 1878. pp.12. [120.]

— Second edition. A list of books in the National art library illustrating furniture. 1885. pp.vi.66. [1000.]
this is now the Victoria and Albert museum.

[PETER JESSEN and JEAN LOUBIER], Möbel und holzarbeiten. Königliche museen zu Berlin: Hauptwerke der bibliothek des Kunstgewerbemuseums (no.1): Berlin 1896. pp.iv.38. [400.]

— — Zweite auflage. 1901. pp.iv.27. [250.]

BRIEF list of books on antique and period furniture. Library of Congress: Washington 1920. ff.3. [33.]*

— [another edition]. A selected list [&c.]. 1936. ff.16. [162.]*

MARIE J. LAGRANGE, Early american furniture. An annotated selective list of books. Indiana state library: Indianapolis 1939. ff.12. [50.]*

R. W. SYMONDS, English furniture. National book league: Reader's guide: 1948. pp.20. [60.]

—— [another edition]. 1951. pp.20. [80.]

Futurism.

ENRICO FALQUI, Bibliografia e iconografia del futurismo. Biblioteca bibliografica italica (vol.21): Firenze 1959. pp.3–242. [1500.]

Gill, Eric.

EVAN R. GILL, Bibliography of Eric Gill. [1953]. pp.xv.235. [664.]

Glass.

A LIST of books and pamphlets in the National art library of the South Kensington museum illustrating glass. 1887. pp.vi.50. [600.]

LIST of books, &c., relating to glass, in the library of the museum. Edinburgh museum of science and art: Edinburgh 1893. pp.40. [500.]

GLASS work. Grosvenor library: Reading lists on arts and crafts: Buffalo, N.Y. 1900. pp.[3]. [37.]

LIST of works in the New York public library relating to ceramics and glass. [New York 1908]. pp.38. [glass: 600.]

Special Subjects

ARBEIDER i ler, sten og glas. Kunstindustri-
museets og Kunst- og haandværksskolens Biblio-
thek: Bøger for haandværkere (no.vii): Kristiania
1908. pp.25. [250.]
— Tillæg. 1909. pp.[4]. [14.]

LIST of references on colored and art glass.
Library of Congress: Washington 1916. ff.16.
[211.]*

SELECTED list of books on ceramics and glass-
ware. Public library of New South Wales: Sydney
1919. pp.12. [200.]

LIST of books on the history and collecting of
glassware. Library of Congress: Washington 1940.
ff.9. [70.]*

[GEOFFREY J. L. GOMME], Books on glass. A
check-list. New York 1942. pp.v.26. [80.]
[—] — [second edition]. 1946. pp.[v].27. [183.]

STAINED glass, modern. Public library of South
Australia: Research service: [Adelaide] 1959. ff.8.
[129.]*

GEORGE SANG DUNCAN, Bibliography of glass
(from the earliest records to 1940). . . . Edited by
Violet Dimbleby. Society of glass technology,
Sheffield: London 1960. pp.viii.544. [15,752.]

Gogh, Vincent van.

[CAROLINE INGEN-HOUSZ], Literatuurlijst Vincent van Gogh. Provinciaal genootschap van kunsten en wetenschappen in Noord-Brabant: Werken (no.36): 's Hertogenbosch [1930.]

CHARLES MATTOON BROOKS, Vincent van Gogh. A bibliography. Claremont colleges: New York 1942. pp.xviii.58. [777.]

Goldsmith's work.

A LIST of works on gold and silversmith's work and jewellery in the National art library. South Kensington museum [*now* Victoria and Albert museum]: 1882. pp.62. [850.]

— Second edition. A list of books and pamphlets in the National art library . . . illustrating gold and silversmiths' work and jewellery. 1887. pp.91. [1250.]

[ALPHONSE] J[EAN] J[OSEPH] MARQUET DE VASSELOT, Bibliographie de l'orfèvrerie et de l'émaillerie en France. Société française de bibliographie: 1925. pp.xii.294. [2750.]

JAN FLAJŠHANS [*and others*], Umělecká výroba keramická, sklářska a zlatnická v literatuře. Universita: Knihovna: Čteme a studujeme (1957, no.3): Praze [1957]. pp.[ii].88. [1500.]

Goya y Lucientes, Francisco José de.

GENARO ESTRADA, Bibliografía de Goya. Casa de España en México: [México] 1940. pp.3–119. [750.]

AGUSTÍN RUIZ CABRIADA, Aportación a una bibliografía de Goya. Junta tecnica de archivos, bibliotecas y museos: Madrid 1946. pp.[iii].201. [950.]

VICENTE CASTAÑEDA [Y ALCOBER], Libros con ilustraciones de Goya. Madrid 1946. pp.3–27. [25.]

Gravelot, Hubert François.

VERA SALOMONS, Gravelot. xviiith century french book-illustrators: 1911. pp.83.[xliii]. [125.]
100 copies printed.

Greenaway, Kate.

FRANCES J[OAN] BREWER, The John S[toughton] Newberry gift collection of Kate Greenway presented to the Detroit public library. Catalogue. [Detroit] 1959. pp.[iv].25. [75.]

Hogarth, William.

FRANK WEITENKAMPF, A bibliography of William Hogarth. Library of Harvard university:

Bibliographical contributions (no.37): Cambridge, Mass. 1890. pp.14. [200.]

STANLEY E. READ, A bibliography of Hogarths books and studies, 1900–1940. De Paul university: Chicago 1941. pp.iii.32. [202.]*

Holbein, Hans.

GEORGES [GRATET-]DUPLESSIS, Essai bibliographique sur les différentes éditions des 'Icones Veteris testamenti' d'Holbein. Nogent-le-Rotrou [printed] 1884. pp.20. [10.]

[FRÉDÉRIC ALEXANDRE] HENRI STEIN, Quatrième centenaire de Hans Holbein. Bibliographie des publications relatives au peintre Hans Holbein (1497–1543). 1897. pp.16. [100.]

Jewellery.

A LIST of books and pamphlets in the National art library . . . illustrating gems. South Kensington [*now:* Victoria and Albert] museum: 1886. pp. [iv].27. [400.]

SELECT list of references on gems and precious stones. Library of Congress: Washington 1908. ff.10. [56.]*

Johnston, Edward.

[JAMES WARDROP], Memorial exhibition to Edward Johnston. Victoria and Albert museum: [1945]. pp.16. [134.]

Labrouste, Pierre François Henri.

THOMAS N. MAYTHAM, Henri Labrouste, architect: a bibliography. American association of architectural bibliographers: Publication (no.5): Charlottesville, Va. 1955. ff.[i].5. [29.]*

Lace.

A LIST of books on lace and needlework in the National art library. South Kensington [now Victoria and Albert] museum: 1879. pp.16. [150.]

ARTHUR LOTZ, Bibliographie der modelbücher. . . . Beschreibendes verzeichnis der stick- und spitzenmusterbücher des 16. und 17. jahrhunderts. Leipzig 1933. pp.xii.275. [500.]

SELECTED list of books on the history of lace and its use. Library of Congress: Washington 1936. ff.3. [25.]*

Leech, John.

C[HARLES] E[DWARD] S[TUART] CHAMBERS, A list of works containing illustrations by John Leech. Edinburgh 1892. pp.[ii].22. [150.]

285 copies printed; interleaved with pages which are blank except for the headline.

CATALOGUE of an exhibition of works by John Leech. Grolier club: New York 1914. pp.xxiii.188. [200.]
240 copies printed.

[BERTHA COOLIDGE], John Leech on my shelves [*or rather on those of W. B. Osgood Field*]. Munich [printed] 1930. pp.315. [200.]
155 copies privately printed.

Lethaby, William Richard.

WILLIAM RICHARD LETHABY. . . . A bibliography of his literary works compiled by the Royal institute of british architects library staff. [Second edition]. 1950. ff.ii.pp.41. [400.]*

Louvre, musée du.

[ALPHONSE] J[EAN] J[OSEPH] MARQUET DE VASSELOT, Répertoire des catalogues du musée du Louvre (1793–1917). Société française de bibliographie: 1917. pp.xv.175. [388.]
— — Deuxième édition. 1927. pp.145. [465.]

Metal-work.

A LIST of books, photographs, &c., in the National art library, illustrating metal work.

South Kensington [*now* Victoria and Albert] museum: 1883. pp.vii.144. [2000.]

KATALOG der fachbibliothek und des lese-zimmers. Internationale ausstellung von arbeiten aus edlen metallen und legirungen: Nürnberg 1885. pp.50. [500.]

[PETER JESSEN and JEAN LOUBIER], Metall. Königliche museen zu Berlin: Hauptwerke der Bibliothek des Kunstgewerbe-museums (no.5): Berlin 1897. pp.iv.24. [200.]

ARBEIDER i bronse, tin og jern, samt ure, mynter, medaljer og segl. Kunstindustrimuseets og Kunst- og haandværksskolens bibliothek: Bøger for haandværkere (no.iv): Kristiania 1907. pp.18. [125.]

Michelangelo Buonarroti.

[LUIGI PASSERINI ORSINI DE RILLI], La bibliografia di Michelangelo Buonarroti e gli incisori delle sue opere. Firenze 1875. pp.xi.331. [1500.]

CHARLES ELIOT NORTON, List of the principal books relating to the life and works of Michel Angelo. Library of Harvard university: Biblio-graphical contributions (no.3): Cambridge, Mass. 1879. pp.12. [100.]

ERNST STEINMANN and RUDOLF WITTKOWER, Michelangelo bibliographie, 1510–1926. Römische forschungen der bibliotheca hertziana (vol.i): Leipzig 1927. pp.xxviii.527. [2107.]

— — — Nachtrag und fortsetzung. Bearbeitet von Hans Werner Schmidt. 1930. pp.30.

Müller, Friedrich.

FRIEDRICH MEYER, Maler Müller-bibliographie. Leipzig 1912. pp.[viii].175. [455.]

Müller, Hans Alexander.

A CATALOGUE of books illustrated by Hans Alexander Mueller. Columbia university library: [New York] 1937. pp.[8]. [18.]

Munch, Edvard.

HANNAH B. MULLER, Edvard Munch. A bibliography. [New York 1951]. pp.30.

Needlework.

A LIST of books on lace and needlework in the National art library. South Kensington museum [*now* Victoria and Albert museum]: 1879. pp.16. [150.]

[PETER JESSEN and GEORG LENZ], Weberei und stickerei. Königliche museen zu Berlin: Hauptwerke der bibliothek des Kunstgewerbe-museums (no.8): Berlin 1909. pp.21. [150.]

ARTHUR LOTZ, Bibliographie der modelbücher.
. . . Beschreibendes verzeichnis der stick- und
spitzenmusterbücher des 16. und 17. jahrhunderts.
Leipzig 1933. pp.xii.275. [500.]

J. J. MARQUET DE VASSELOT and ROGER ARMAND
WEIGERT, Bibliographie de la tapisserie, des tapis
et de la broderie en France. Société de l'histoire
de l'art français: 1935. pp.iii–xvi.354. [4000.]

KATHLEEN M. HARRIS, Embroidery. National
book league: Readers' guide: 1950. pp.20. [100.]

STANDARD guide to embroidery and other
needlework books. [1961]. pp.48. [250.]

Office buildings.

LIST of references on the management and care
of office buildings and similar structures. Library
of Congress: [Washington] 1923. ff.8. [81.]*

OFFICES — layout. Public library of South
Australia: Research service: [Adelaide] 1957. ff.3.
[51.]*

Perspective.

A LIST of books and pamphlets in the National
art library . . . on drawing, geometry, and per-
spective. South Kensington museum: 1888. pp.92.
[1000.]

Picasso, Pablo Ruiz.

MAURICE BRIDEL, Notes pour une bibliographie des ouvrages illustrés par Pablo Picasso. [Lausanne] 1954. pp.[7]. [64.]

H[ENRI] MATAROSSO, Bibliographie des livres illustrés par Pablo Picasso. Œuvres graphiques — 1905–1956. Nice 1956. pp.20. [74.]

ABRAHAM HORODISCH, Pablo Picasso als buch-künstler, mit einer bibliographie. Gesellschaft der bibliophilen: Frankfurt am Main 1957. pp.82.50. [200.]

Pocci, Franz.

FRANZ POCCI, Das werk des künstlers Franz Pocci. Ein verzeichniss seiner schriften, komposi-tionen und graphischen arbeiten, zusammenge-stellt von Franz Pocci (enkel). Einzelschriften zur bücher- und handschriftenkunde (vol.v): Mün-chen 1926. pp.[iv].176. [725.]

Portraits.

LIST of books indexed in the A.L.A. portrait index. Library of Congress: Washington 1906. pp.lxxiv. [1250.]

SIGFRID H[ENRY] STEINBERG, Bibliographie zur geschichte des deutschen porträts. Historische

bildkunde (no.1): Hamburg 1934. pp.vii.166. [1101.]

CARL [ALGOT PETER] BJÖRKBOM and BOO [FREDERIK] VON MALMBORG, Svensk porträttlitteratur. Bibliografisk förteckning. [Nationalmuseum]: Svensk porträttarkiv: Publikationer (vol.iii): [Stockholm 1941]. pp.171. [1826.]

Post cards.

LIST of references on picture post cards. Library of Congress: Washington 1916. ff.2. [22.]*

Proportions.

[AGNOLDOMENICO PICA], Studi sulle proporzioni. Mostra bibliografica. Nona triennale: Convegno internazionale su le proporzioni nelle arti: Milano 1951. pp.26. [200.]

Rackham, Arthur.

FREDERICK COYKENDALL, Arthur Rackham. A list of books illustrated by him. Mount Vernon, N.Y. 1922. pp.[iv].23. [55.]
175 copies privately printed.

SARAH BRIGGS LATIMORE and GRACE CLARK HASKELL, Arthur Rackham, a bibliography. Los Angeles 1936. pp.xiii.112. [200.]

BERTRAM ROTA, The printed work of Arthur Rackham. [1960]. pp.20. [250.]

Raphael Sanzio.

EUGÈNE MÜNTZ, Les historiens et les critiques de Raphaël, 1483–1883. Essai bibliographique. Bibliothèque internationale de l'Art: 1883. pp.[iii]. 174. [1000.]

Rosa, Salvatore.

FERDINAND GERBA, Salvator Rosa e la sua vita romana dal 1650 al 1672 in un carteggio inedito con Giovan Battista Ricciardi. Roma 1937. pp.64. [200.]

UMBERTO LIMENTANI, Bibliografia della vita e delle opere di Salvator Rosa. Amor di libro: Piccole monografie bibliografiche (no.xix): Firenze 1955. pp.80. [147.]

333 copies printed.

Rowlandson, Thomas.

CATALOGUE of books illustrated by Thomas Rowlandson. Grolier club: New York 1916. pp. xiv.110. [70.]

Rubens, sir Peter Paul.

LITERATUUR over Rubens. Hoofdbibliotheek: Antwerpen 1927. pp.90. [1000.]

PROSPER ARENTS, Geschrifften van en over Rubens. Comité Rubensherdenking: Antwerpen 1940. pp.894. [6000.]

ANVERS ville de Plantin et de Rubens. Catalogue de l'exposition organisée à la Galerie mazarine. Bibliothèque nationale: 1954. pp.271. [444.]

Ruzicka, Rudolph.

THE ENGRAVED & typographic work of Rudolph Ruzicka. An exhibition. Grolier club: New York 1948. pp.37. [233.]
 500 copies printed.

St Peter's church, Rome.

[FRANCESCO CANCELLIERI], Descrizione della Basilica vaticana con vna biblioteca degli avtori che ne hanno trattato. Roma 1788. pp.144. [60.]

Sculpture.

CHRISTOPHE THÉOPHILE DE [CHRISTOPH GOTTLIEB VON] MURR, Bibliothèque de peinture, de sculpture, et de gravure. Francfort &c. 1770. pp.[xvi]. 406+407–778.[xxviii]. [4000.]

A LIST of works on sculpture in the National art library. South Kensington museum [*now:* Victoria and Albert museum]: 1882. pp.[ii].32. [500.]
 — Second edition. 1886. pp.viii.154. [2250.]

BERTHOLD HAENDCKE, Architectur, plastik und malerei. Centralkommission für schweizerische landeskunde: Bibliographie der schweizerischen landeskunde (section v.6 a–c): Bern 1892. pp.ix. 100. [sculpture: 125.]

[PETER JESSEN and JEAN LOUBIER], Dekorative plastik. Königliche museen zu Berlin: Haupt-werke der bibliothek des Kunstgewerbe-museums (no.3): Berlin 1896. pp.iv.29. [250.]

LIST of references on chinese sculpture (supple-menting list prepared by Cleveland museum of art). Library of Congress: Washington 1920. ff.7. [76.]*

BRIEF list of references on the art of sculpture, with emphasis upon the technical side. Library of Congress: Washington 1929. single leaf. [10.]*

CLASSIC art: sculpture. Cincinnati museum library: Book list (no.2): Cincinnati [*n.d.*]. pp.[4]. [30.]

ERIC H[YDE] L[ORD] SEXTON, A descriptive and bibliographical list of irish figure sculptures of the early christian period. Portland, Me. 1946. pp. xxvii.305. [1000.]

СКУЛЬПТУРА. Государственная публичная

библиотека имени Салтыкова-Щедрина : [Leningrad 1916]. pp.12. [30.]

JULIE JONES, Bibliography for olmec sculpture. Museum of primitive art: Primitive art bibliographies (no.2): New York 1963. pp.[ii].8. [200.]*

Silversmiths' work.

A LIST of works on gold and silversmith's work and jewellery in the National art library. South Kensington museum [*now:* Victoria and Albert museum]: 1882. pp.62. [850.]

— Second edition. A list of books and pamphlets in the National art library . . . illustrating gold and silversmiths' work and jewellery. 1887. pp.91. [1250.]

Société de l'histoire de l'art français.

RÉPERTOIRE des publications de la Société de l'histoire de l'art français.

1851–1927. Par [Alphonse] J[ean] J[oseph] Marquet de Vasselot. 1930. pp.ii.xxxii.219. [5000.]

1928–1956. Par J. J. Marquet de Vasselot [and Roger Armand Weigert]. 1958. pp.viii.131. [1000.]

Stone.

ARBEIDER i ler, sten og glas. Kunstindustri-

museets og Kunst- og haandværksskolens biblio-
thek: Bøger for haandværkere (no.vii): Kristiania
1908. pp.25. [250.]
— Tillæg. 1909. pp.[4]. [14.]

Surrealism.

HUGH [L.] EDWARDS, Surrealism & its affinities.
The Mary Reynolds collection. A bibliography.
Art institute: [Chicago] 1956. pp.132. [356.]

Town halls.

TOWN halls. Public library of South Australia:
Research service: [Adelaide] 1957. ff.3. [41.]*

United States capitol.

ANN DUNCAN BROWN, The United States
capitol. A selected list of references. Library of
Congress: General reference and bibliography
division: Washington 1949. pp.[iii].34. [176.]*
*this is a supplement to the bibliography in Glenn
Brown,* History of the United States capitol (*1903*).

Vinci, Leonardo da.

GIOVANNI DOZIO, Degli scritti e disegni di
Leonardo da Vinci e specialmente dei posseduti
un tempo e dei posseduti adesso dalla biblioteca
Ambrosiana. Milano 1871. pp.47. [40.]

JULIUS VON SCHLOSSER, Materialen zur quellen-

kunde der kunstgeschichte . . . III. Erste hälfte des cinquecento: Leonardos vermächtnis — historik und periegese. Kaiserliche akademie der wissenschaften: Sitzungsberichte: Philosophisch-historische klasse (vol.clxxx, no.5): Wien 1916. pp.76. [300.]

LUCA BELTRAMI, Bibliografia vinciana, 1885–1919. Roma [printed] 1919. pp.21. [90.]

ETTORE VERGA, Gli studi intorno a Leonardo da Vinci nell'ultimo cinquantennio (1872–1922). Istituto di studii vinciani: Opuscoli vinciani (vol.i): Roma 1923. pp.[viii].151. [300.]

ETTORE VERGA, Bibliografia vinciana, 1493–1930. Bologna 1931. pp.iii–xii.404+[iv].405–839. [2900.]

MAUREEN COBB MABBOTT, A check list of the editions of Leonardo da Vinci's works in college and public libraries in the United States. Public library: New York 1935. pp.10. [113.]

MAUREEN COBB MABBOTT, Catalogue of the Lieb memorial collection of Vinciana. Stevens institute of technology: Hoboken, N.J. 1936. pp.xi.103. [1000.]

KATE TRAUMAN STEINITZ and MARGOT ARCHER,

The Elmer Belt library of Vinciana. Finding list [Los Angeles 1947]. ff.[iii].v.81. [1250.]*

KATE TRAUMAN STEINITZ and MARGOT ARCHER, Manuscripts of Leonardo da Vinci. Their history, with a description of the manuscript editions in facsimile. Elmer Belt library of Vinciana: Los Angeles 1948. pp.vi.70. [40.]

QUINTO centenario della nascita di Leonardo da Vinci. Mostra di disegni, manoscritti e documenti. Biblioteca medicea laurenziana: Firenze [1952]. pp.82. [155.]

CARLO PEDRETTI, Docvmenti e memorie rigvardanti Leonardo da Vinci a Bologna e in Emilia. Bologna 1953. pp.iii–xvi.333. [120.]

CATALOGUE de l'exposition des éditions des carnets Léonard de Vinci du xvii^e siècle à nos jours. Musée des beaux-arts: Tours [1954]. pp.xxvi.18. [162.]

KATE TRAUMAN STEINITZ, Leonardo da Vinci's Trattato della pintura. . . . A bibliography of the printed editions 1651–1956 based on the complete collection in the Elmer Belt library of Vinciana. University library: Library research monographs (vol.5): Copenhagen 1958. pp.245. [100.]

War memorials.

FRANK WEITENKAMPF, War memorials. A list of references in the New York public library. New York 1919. pp.10. [150.]

KATHERINE MCNAMARA, War memorials. Harvard university: Library of the Department of landscape architecture and regional planning: [Cambridge 1944]. ff.5. [100.]★

White house, The.

A LIST of references on the White house. Library of Congress: [Washington] 1924. ff.9. [36.]★

ANN DUNCAN BROWN, The White house. A bibliographical list. Library of Congress: General reference and bibliography division: Washington 1953. pp.vi.139. [579.]★

BESS GLENN, Preliminary inventory of the records of the Commission on the renovation of the executive mansion. National archives: Preliminary inventories (no.117): Washington 1959. pp.v.9. [25,000.]★

Woodwork.

[PETER JESSEN and JEAN LOUBIER], Möbel und holzarbeiten. Königliche museen zu Berlin:

Hauptwerke der bibliothek des Kunstgewerbe-
museums (no.1): Berlin 1896. pp.iv.38. [400.]

—— Zweite auflage. 1901. pp.iv.27. [250.]

T. REED, Woodwork. A selection of books.
National book council: Book list (no.123): 1930.
pp.[2]. [60.]

Wright, Frank Lloyd.

[BERNARD KARPEL], What men have written
about Frank Lloyd Wright. A bibliography . . .
from 1900 to 1955. [*s.l.* 1955]. pp.34. [330.]*